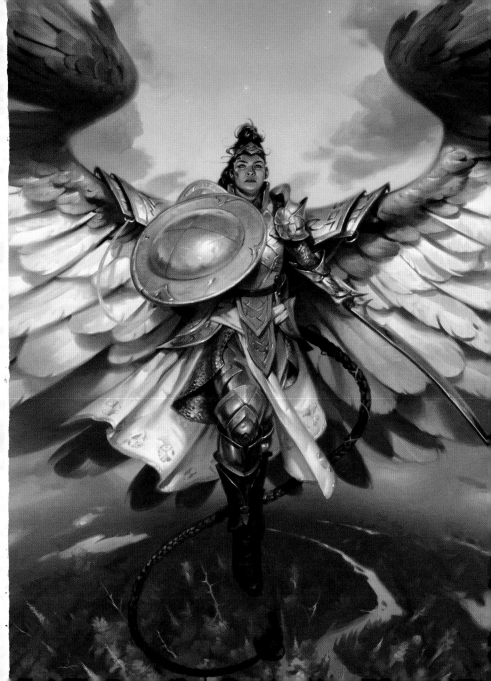

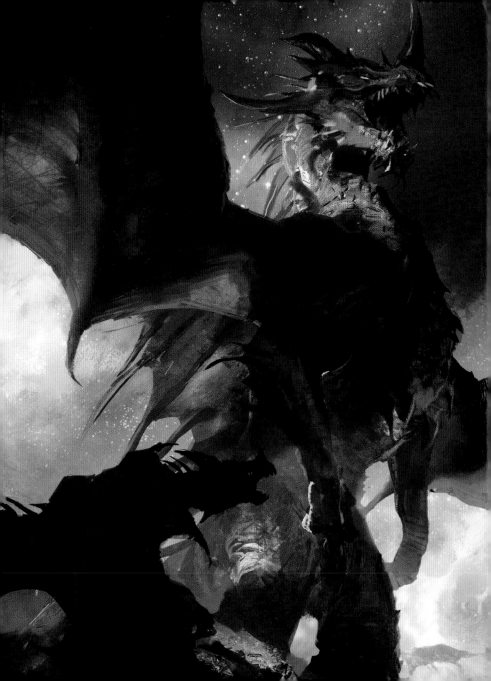

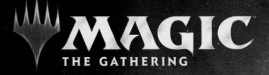

MAGIC
THE GATHERING

LEGENDS

A VISUAL HISTORY

Jay Annelli

Abrams, New York

CONTENTS

FOREWORD

The year was 1999. I, a young teen, had just begged my parents to buy me a pack of the brand-new set of *Magic: The Gathering*® cards, *Mercadian Masques*™. On the car ride home, I flipped through my prize with wonder. Opening the pack, most were creatures and spells I had never heard of before. The creature Horned Troll looked neat! Lightning Hounds were definitely cool. Those cards were great, but it was the rare one in the back of the pack that captured my imagination: Squee, Goblin Nabob, complete with art depicting a goofy-looking goblin in full leadership regalia. This wasn't just a creature like the others, but a Goblin *Legend*. Who *was* this creature who was cool enough to be called a Legend? I had to know more.

Legends in *Magic* have that effect. While the game itself, with its magical spells and fantastical creatures, conveys the fantasy theme, it's the characters who sell the diverse worlds of *Magic*'s Multiverse. And there are hundreds of them, with dozens more printed every year. It's not unlikely that *Magic* will have printed a thousand Legendary Creature cards within the next couple years. Not all of these Legends have elaborate backstories or feature into epic fantasy

Brago's Favor ➤ **Karla Ortiz**

sagas, but they do give players someone—or something—to identify with.

Legends were introduced early in *Magic*'s history with the aptly named *Legends* set in 1994. They quickly captured the players' imaginations, especially the Elder Dragons. Legends, or Legendary Creatures as they came to be known, proved to be so popular that they've been printed in almost every product since. They have also inspired one of the most popular and enduring formats in the game, Commander.

Originally, the stories of these Legends were left vague, and it was up to the players' imaginations to fill in the blanks. As time went on and *Magic* delved into the realm of epic fantasy sagas, many of the characters behind the cards were fleshed out. Characters from the story were printed as Legends, and Legends that were printed before the story made their way into the narrative.

The printing of Legends became a narrative tool, showing different states of characters as time progressed. We first saw this with the character Crovax, who was printed as Crovax the Cursed in *Stronghold*™. Crovax was a member of the crew of the legendary skyship *Weatherlight* and in a cruel twist of fate was cursed to become a vampire. The vampiric Crovax turned on his former crew and joined the evil Phyrexia, obtaining the title of Evincar

▲ **Crovax the Cursed** ▶ Pete Venters

and appearing next on the card Ascendant Evincar when the story's spotlight returned to him.

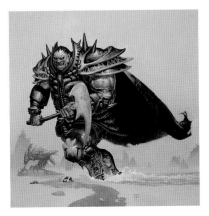

This technique of presenting *Magic*'s story through its characters, or telling a story through the changes made to Legends over time, was used more and more as the years went on. Some characters have appeared three, even four times. As someone who has obsessed over all the details in *Magic*'s story and has written more than a hundred articles on the topic, I was incredibly pleased to be asked to bring the stories of these Legends to you through this book.

Some of the characters you'll find in these pages are among the most famous in *Magic*; you'd be hard-pressed to find a *Magic* player who has never heard of Avacyn. Some of the characters have more words written about them in this book than you'll find in all of *Magic*'s other publications combined. They were picked for both their impact and their diversity, to give you a sampling of the unique and varied creatures and worlds in *Magic: The Gathering*. Whether you've never heard of *Magic* before picking up this book or you've been playing since Urza was just a name associated with glasses and weird hats, I hope you enjoy the fantastic artwork and brief biographies of the characters presented throughout.

▲ **Ascendant Evincar** ▷ **Mark Zug**

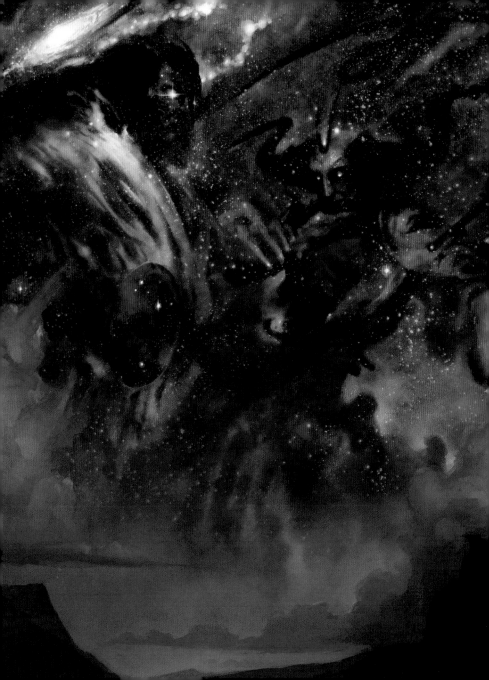

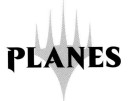

PLANES

Magic: The Gathering's worlds, called planes, are part of a vast Multiverse as varied as it is dangerous. While almost all of the characters you'll be introduced to in this book call only a single plane home, there are beings capable of traveling the Blind Eternities, the veil that exists between planes. These beings are called planeswalkers, and each of them carries the imprint of the Blind Eternities on their soul. That imprint is called a spark, and for most it lies dormant their entire lives. When exposed to the most extreme emotions, that spark will ignite and allow them to travel between planes.

Magic: The Gathering spent much of its early years on a plane known as Dominaria, building an epic history that spanned millennia. After a decade spent mostly on Dominaria, the story began to explore new worlds across the Multiverse. Of these new worlds, the city-plane of Ravnica became a massively popular destination, and the cosmopolitan setting lent itself well to becoming the new story hub. Today, Ravnica has been the setting for more card sets than any plane since Dominaria.

Starfield of Nyx ► Tyler Jacobson

While some of the characters you'll see today may have the planeswalker spark, most will have had their lives touched by a planeswalker or other beings from exotic planes. In this book, we'll talk about creatures from *Magic*'s most iconic locales, from vibrant planes with deep histories to dark worlds of horror where life hangs by the smallest of threads.

Ravnica A city-plane ruled by ten rival guilds, bound together by the magical Guildpact.

Dominaria A plane with a storied history, flourishing despite the apocalyptic events that once devasted it.

New Phyrexia A plane of mathematical precision once known as Mirrodin, twisted by dark forces lurking at its core.

Alara A plane sundered centuries ago into five shards, suddenly reunited after millennia apart.

Zendikar A plane torn apart by a roiling landscape, where adventure—and eldritch secrets—lurk in the remnants of ancient civilizations.

Innistrad A plane where humanity is made a meal by every dark creature that goes bump in the night.

Theros A plane where capricious gods are shaped by the myths told about them.

Fiora A plane of intrigue, where betrayals and conspiracies abound in the High City of Paliano.

Tarkir A plane where an altered fate has replaced warring human clans with draconic overlords.

Kaladesh A plane of invention that embodies bright optimism and the creative spirit.

Amonkhet A desert plane where death is only the beginning and the gods themselves were abused by a darker power.

Ixalan A plane of exploration and adventure, where vampiric conquistadors vie for ancient treasure against a dinosaur empire, pirates, and merfolk tribes.

Eldraine A plane where the fae were long ago driven out of the human Realm and forced to inhabit the Wilds.

Ikoria A plane dominated by behemoths where humanity survives in rare protected cities or by bonding with the fearsome creatures.

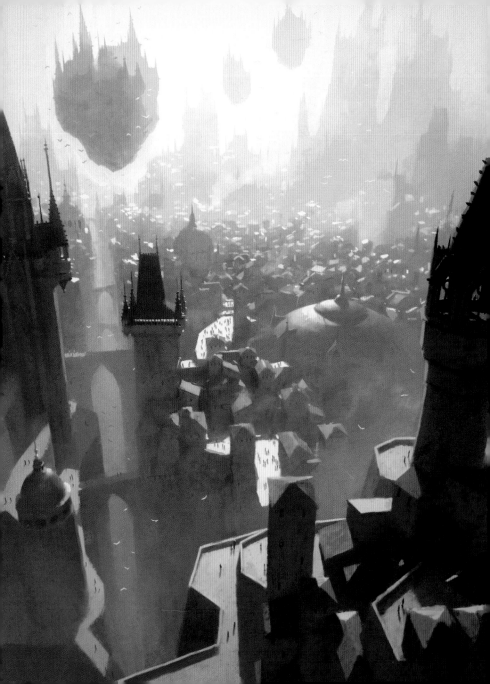

RAVNICA

Ten thousand years ago, the leaders of ten warring factions came together on Ravnica to sign an accord. This agreement, known as the Guildpact, magically bound the ten factions together as guilds. Each of these newly formed guilds was responsible for an essential function of Ravnican society. For millennia, the Guildpact brought prosperity and balance to the guilds. A great city was born, quickly growing to consume the majority of the plane.

The Azorius Senate established a legislature, judiciary, and policing force. House Dimir became couriers and information brokers backed by a network of spies and assassins. The Cult of Rakdos provided labor and entertainment. The Gruul Clans worked to keep civilization from spreading too far, while the Selesnya Conclave blended nature into the sprawling city. The Orzhov Syndicate became bankers and lawyers, and the Izzet League provided public works. The Golgari Swarm recycled and reclaimed the city's refuse. The Boros Legion maintained order with their standing army, and the Simic Combine provided for the public health.

The ten guilds lived in relative peace until the Guildpact was shattered by the greed of several guildmasters. In the chaos that followed, without the Guildpact, the guilds began to fall apart until a fail-safe was uncovered. If the ten guilds could show they could work together again, a new Living Guildpact, embodied in a person, could be established. The planeswalker Jace Beleren became the Living Guildpact for several years until the invasion of the evil elder dragon Nicol Bolas. Nicol Bolas broke the Guildpact once more, but the unity of the guilds reforged it, this time embodied in the dragon Niv-Mizzet.

Plains ↣ Richard Wright

Firemind's Research ✒ Grzegorz Rutkowski

Niv-Mizzet, Parun ✒ Svetlin Velinov

Niv-Mizzet

Niv-Mizzet is the last of his kind on Ravnica, a breed of intelligent dragon that once dominated the plane. Hatched over sixteen millennia ago, the ambitious dragon founded the Izzet League, a guild made up of science-mages whose experiments most often end in explosions. Niv-Mizzet himself is known as the Firemind for his unparalleled intellect and led the guild for over ten millennia. In a last-ditch plan to stop the interplanar tyrant Nicol Bolas, Niv-Mizzet died and was reborn as the Living Guildpact, the arbiter between the ten rival guilds of Ravnica

▲ **Niv-Mizzet, the Firemind** ☛ **Daarken**

"Don't I just have an idea—
have all of them." —Niv-Mizzet

ENTER THE INFINITE

iv-Mizzet Reborn
▷ Raymond Swanland

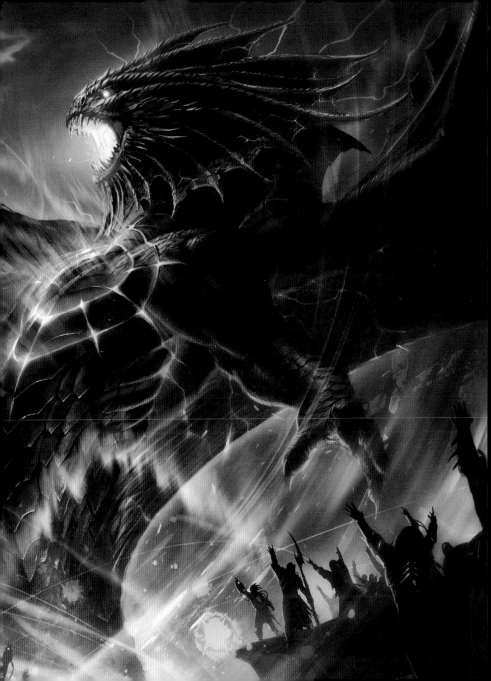

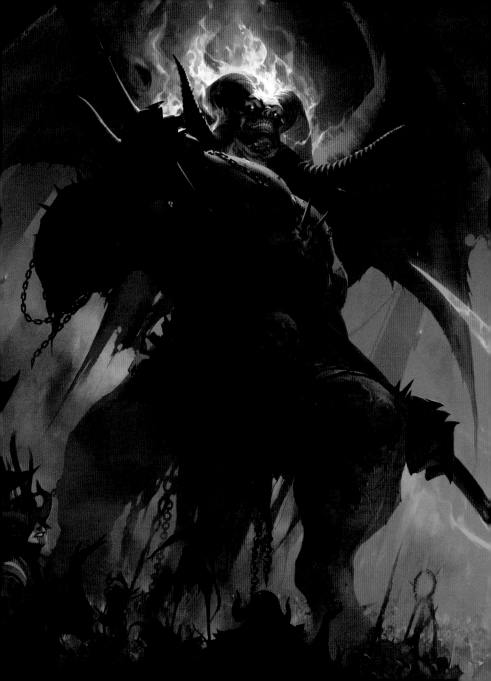

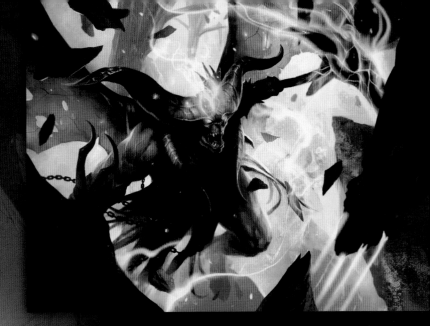

Rakdos

In the ten millennia since the formation of his namesake guild, the demon Rakdos has most often languished in his pit, seeking only to be entertained. Across Ravnica, the Cult of Rakdos is known for their hedonistic indulgences and gruesome performances, all in the service of entertaining their dark master. Rakdos is rarely content for long, however. It's only a matter of time before the ancient demon emerges once more to wreak havoc on the plane in another grand performance.

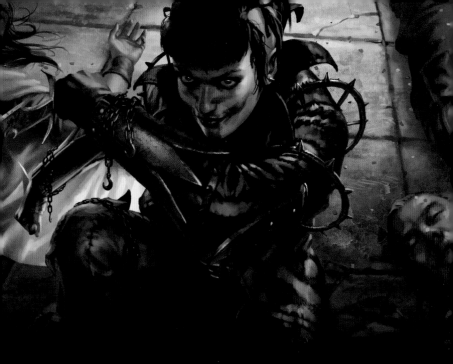

Massacre Girl

Ravnica's most wanted criminal, the assassin known only as Massacre Girl leaves an unparalleled streak of carnage in her wake. Every attempt to arrest her only adds to her body count, and all of the evidence against her—including the buildings it has been housed in—always seems to end up in flames. Massacre Girl's bloody work is conducted in the service of her demonic master, Lord Rakdos. Whether the chaos she spreads points to some larger goal or is simply her idea of a good time has never been clear.

▲ **Massacre Girl** ✍ **Chris Rallis**

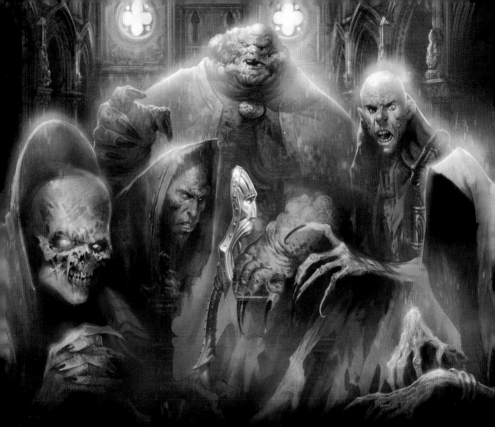

The Obzedat

The Orzhov Syndicate, known as the Church of Deals, was once ruled by the avarice of its long-dead guildmasters, the Ghost Council, formally known as the Obzedat. While the membership of the Ghost Council changed as personal fortunes waxed and waned, the unrivaled greed of its spectral oligarchs did not. So enamored were they with their self-importance that they failed to notice the ghost-assassin planeswalker Kaya in their midst. By the time they realized she could reach beyond the veil and dispatch them for good, it was too late.

Obzedat, Ghost Council ◆ Svetlin Velinov

Teysa Karlov

Teysa Karlov became the esteemed matriarch of the
Karlov family upon the assassination of her loath-
some grandfather and the rest of the Ghost Council.
With her deepest ambition fulfilled, Teysa was left
with a new problem: Kaya, the new guildmaster, had
begun forgiving debts, which threatened to destabi-
lize the entire system. Now Teysa labors in secret to
position herself as the true power behind the guild.

▲ Teysa Karlov ▻ Magali Villeneuve

▸ Teysa, Envoy of Ghosts ▻ Karla Ortiz

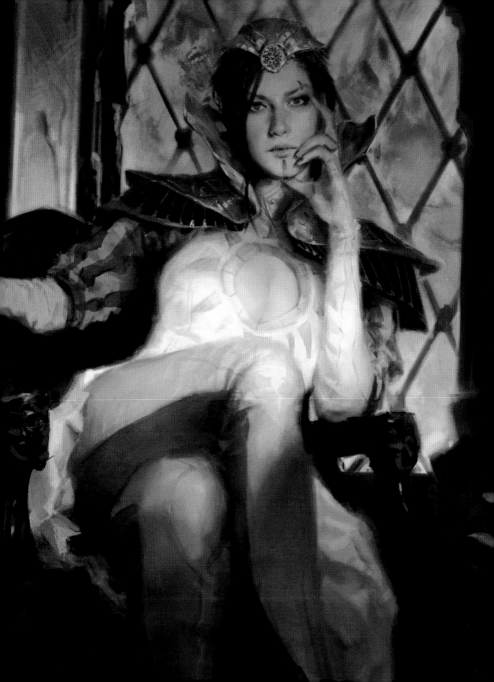

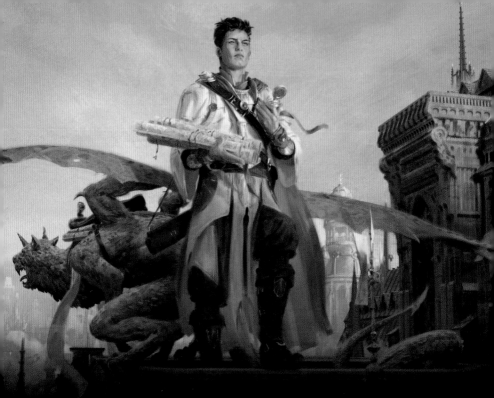

Tomik Vrona

The sharpest young legal mind on his home plane of Ravnica, Tomik Vrona was raised by the ghosts of his parents to become a distinguished advokist, a master of law magic. Tomik's earnest belief in the law sometimes puts him at odds with his guild, the Orzhov Syndicate, and their tendency to manipulate the law for personal gain. Now running the guild he'd dedicated his life to, with the love and support of Izzet guildmaster Ral Zarek, his incorruptible spirit is bound to reform the Syndicate into the best it could be.

Tomik, Distinguished Advokist ▸ Johannes Voss

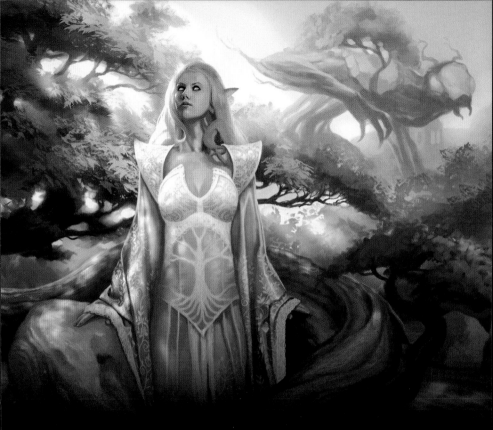

Emmara Tandris

The elven cleric Emmara Tandris brings succor to her allies and the crushing weight of arboreal elementals to her foes. A respected member of the Selesnya Conclave, the guild of unity and nature, Emmara has come to realize the collectivism of her beloved Conclave requires a strong dissenting voice from time to time. This attitude frequently puts her at odds with her fellow guild members, who recognize how Emmara has saved the Conclave from disaster in the past but resent a single person being held with such high esteem in the guild.

▲ **Emmara Tandris** ➤ **Mark Winters**

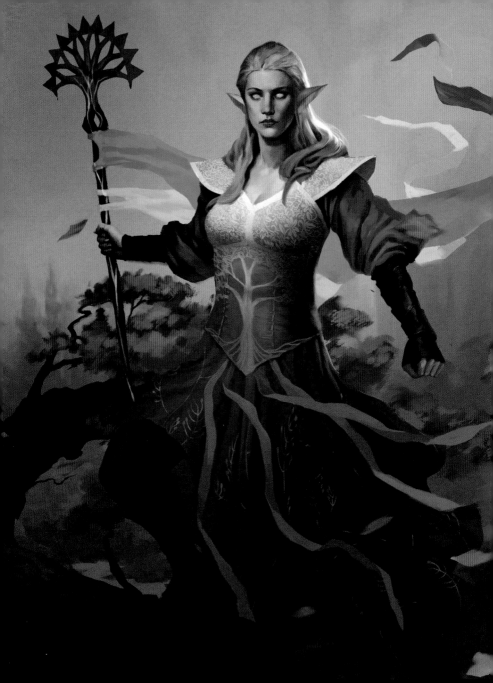

"There is nothing stronger than many hearts united for a single cause."
—Emmara

MIGHT OF THE MASSES

◄ Emmara, Soul of the Accord ▻ Mark Winters

▲ Faces of Ravnica: Emmara Tandris ▻ Wesley Burt

Trostani

The triumvirate known as Trostani was once three individ-
ual dryad sisters, now merged in a symbol of the Selesnya
Conclave's devotion to unity. Trostani endeavors to lead the
guild into a more harmonious future. She communes with
the will of nature itself to determine the proper course of
action for the guild, and, by extension, the entire plane.

▲ Trostani, Selesnya's Voice ⮞ Chippy

▶ Trostani Discordant ⮞ Chase Stone

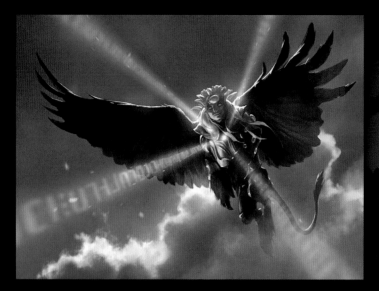

Isperia

The wise and ancient sphinx Isperia was once considered the voice of the law on Ravnica. Her guild, the Azorius Senate, legislates and enforces the law magic that suffuses the ten guilds of the plane. Over the millennia, Isperia was happy to remain aloof from the day-to-day functions of the guild, but a leadership vacuum required she step in to take a direct role as the guild's leader.

What is legal and what is just are often not the same, as Isperia came to learn. When she was confronted by the leader of the Golgari Swarm, the gorgon Vraska, Isperia had no defense for her callous past behavior. Vraska used her petrifying gaze to turn the massive sphinx to stone in her own senate chamber.

- ▲ Sphinx's Revelation ➤ Slawomir Maniak
- ▸ Isperia, Supreme Judge ➤ Scott M. Fischer

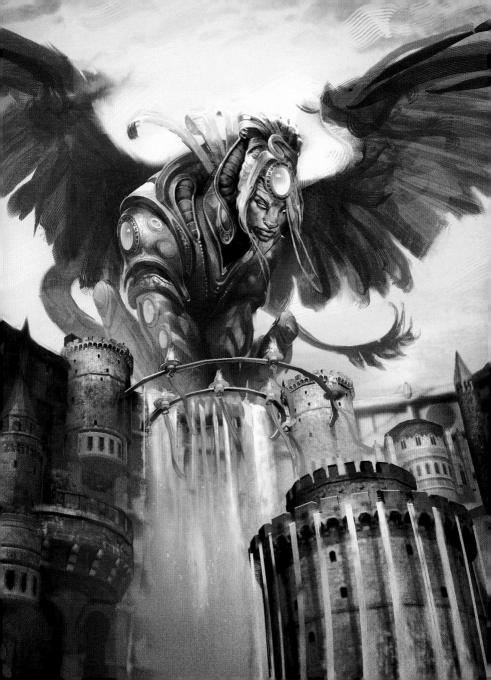

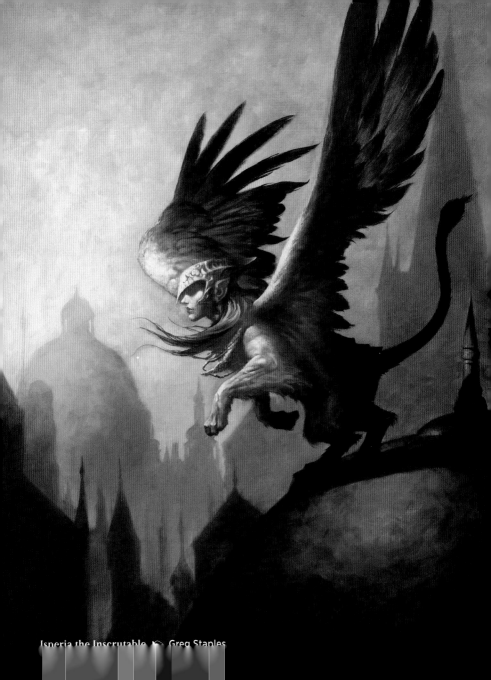

Isperia the Inscrutable ❧ Greg Staples

Guild Summit ◈ Sidharth Chaturvedi

Assassin's Trophy ◈ Seb McKinnon

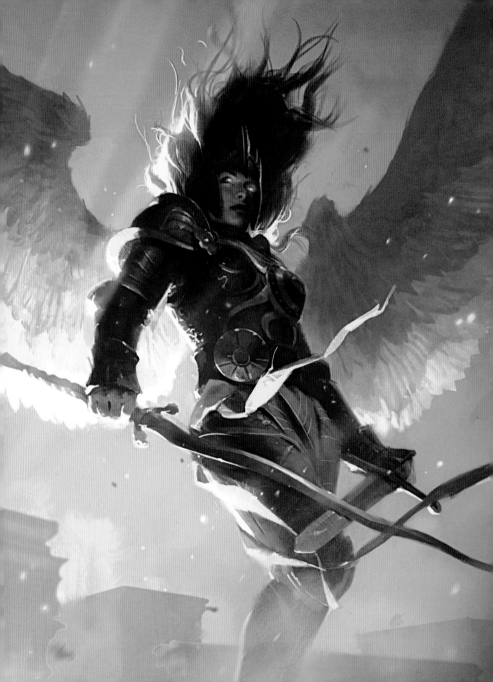

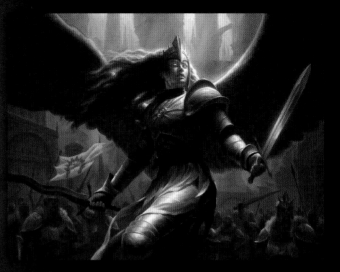

Aurelia

The angelic Warleader Aurelia ascended to the leadership of the militaristic Boros Legion after ousting the previous guildmaster, a penitent angel with a checkered past. As guildmaster, she believes in leading her guild from the front, charging into battle alongside her troops. Over the years her hard-line stance has softened, and she has seen the value in solutions that don't always lead with blades.

Aurelia's Legion is focused on doing the right thing first and dealing with the paperwork later. This attitude is exemplified by Aurelia's uplifting the ousted guildmaster back to a position of leadership in the guild. Aurelia's mere presence inspires hope in the darkest of hours.

◄ **Aurelia, Exemplar of Justice** ✒ Chris Rahn

▲ **Aurelia, the Warleader** ✒ Slawomir Maniak

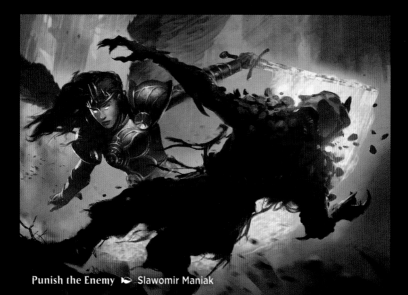

Punish the Enemy ▶ Slawomir Maniak

Chance for Glory ▶ Bram Sels

"If we cannot have peace, we will have justice." —Aurelia

ANGELIC EXALTATION

Lazav

The mutable leader of the spies and assassins of
House Dimir is a shapeshifter of exceptional skill.
Lazav's past is mysterious, but his hold on the Dimir
is unquestioned. While on the surface the Dimir pro-
vide many valuable services to Ravnica, from couriers
to librarians, covertly the Dimir are monitoring every
aspect of Ravnican life. Lazav's mercurial nature
makes it difficult to determine his ultimate goals.
Where secrets are to be had, Lazav's Dimir are there.

▲ **Lazav, Dimir Mastermind** ✎ David Rapoza

▶ **Lazav, the Multifarious** ✎ Yongjae Choi

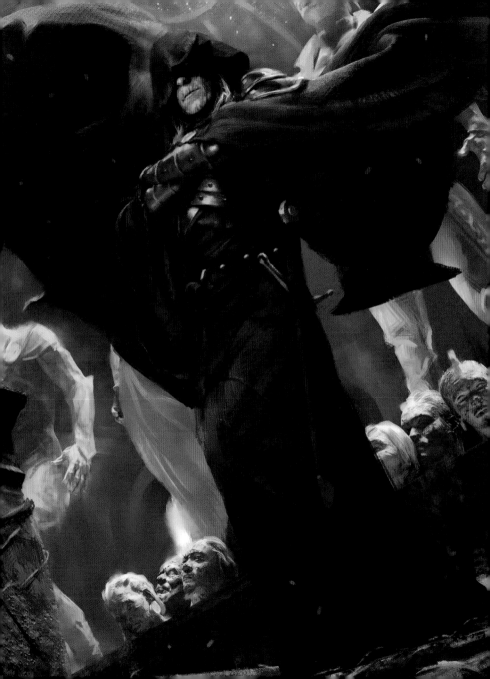

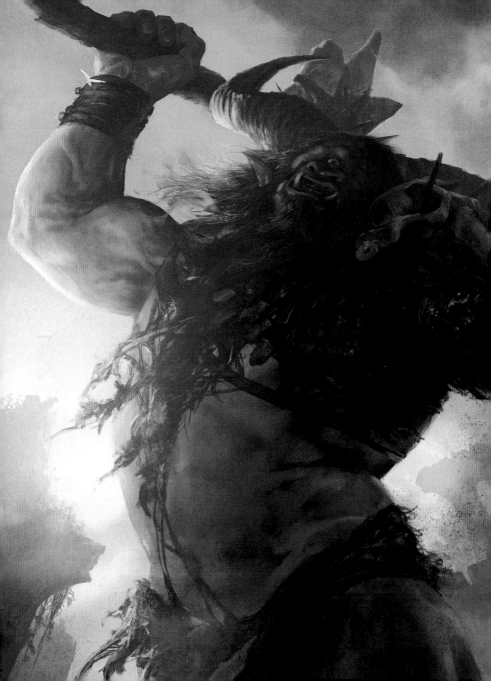

Borborygmos

Borborygmos is the massive and feral cyclopean chieftain of the wild guild known as the Gruul Clans. While the disparate clans of the guild make war on Ravnica, and with one another, Borborygmos is respected and feared by all in equal measure. Unlike other guilds that hatch complex schemes, Borborygmos and the Gruul who follow him want only to smash civilization.

◄ **Borborygmos Enraged** ✎ Aleksi Briclot

▲ **Borborygmos** ✎ Todd Lockwood

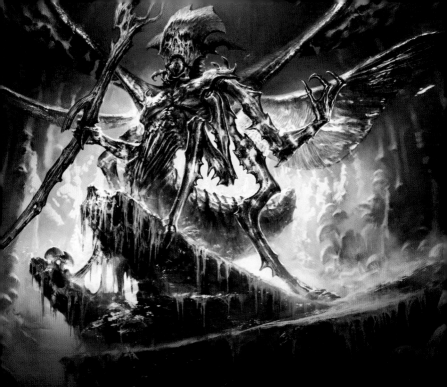

Mazirek

Mazirek was the leader of the insectile kraul, a race on the fringes of the subterranean guild of life and death known as the Golgari Swarm. Tired of the disrespect the elvish leadership of the guild heaped upon his people, Mazirek unearthed an ancient vault of zombies. With this new army, Mazirek lead a coup against the Golgari leadership. The power he gained came with a price: service to the invading elder dragon Nicol Bolas. To serve Bolas, Mazirek worked against the good of the plane to save his people. When his duplicitous ways were revealed, the traitorous death priest was executed.

▲ **Mazirek, Kraul Death Priest** ◣ **Mathias Kollros**

Krenko

The alleged leader of a goblin criminal cartel, Krenko is as elusive as he is volatile. While his initial rise came on the back of his partnership with the secretive House Dimir, Krenko has come into his own in recent years. Although he overplayed his hand in a goblin turf war and was arrested, Krenko escaped custody and is once more on the lam. With some newfound cash in his pocket, the sky's the limit as Krenko sets about rebuilding his criminal empire.

▲ Krenko, Mob Boss ➥ Karl Kopinski

Fblthp

The put-upon homunculus Fblthp is but a simple civil servant with no sense of direction. His diminutive stature and anxious personality leave him frequently lost, stumbling into one dangerous situation after another. In a world-city as vast and complex as Ravnica, there's no shortage of trouble a homunculus with a poor sense of direction can get into.

▲ Fblthp, the Lost 🖎 Jesper Ejsing

Totally Lost ⤳ David Palumbo

Totally Lost ⤳ Aaron Miller

DOMINARIA

Dominaria has seen the rise and fall of countless empires and endured more apocalyptic events than any other plane in the Multiverse. The Elder Dragon War saw the ancient dragons spawned by the Ur-Dragon turn on each other in a conflict orchestrated by the evil elder dragon planeswalker Nicol Bolas. The Thran Empire, human artificers of exceptional skill, built a massive empire across the plane only to vanish mysteriously, leaving behind bewildering technological marvels. The Thran returned millennia later as Phyrexia, having been twisted into horrific fusions of flesh and machine by their lord, Yawgmoth.

The planeswalker Urza spent his life trying to destroy Phyrexians. He unleashed a massive blast that ushered in an ice age to stop their first incursion. In his war, Urza created a collection of artifacts called the Legacy to defeat Phyrexia, culminating in the skyship *Weatherlight*. With the artifacts combined, he unleashed the Legacy Weapon to end Yawgmoth once and for all. In the aftermath, the silver golem Karn ascended as a planeswalker.

In the centuries since the Phyrexian Invasion, the plane was threatened by time rifts caused by the ancient magical power unleashed there. The planeswalker spark was forever altered here to stop the rift threat, enraging the once omnipotent Nicol Bolas. As the crisis ended, Bolas began a decades-long campaign to regain his lost power. When one of his demonic minions took control of the nefarious Cabal, the *Weatherlight* was rebuilt to end this new threat to the plane.

Memorial to Genius ✒ James Paick

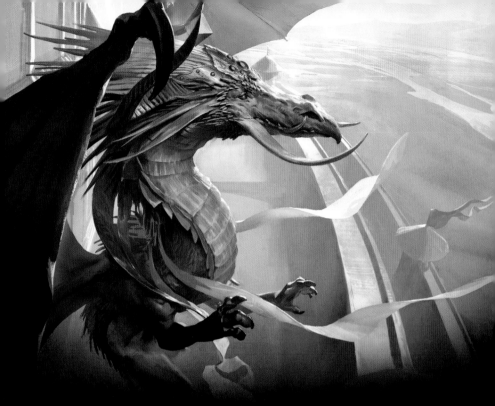

Arcades Sabboth

The first elder dragon, Arcades Sabboth, valued law and order above all else. Arcades saw the chaos of tribal humanity and brought to them civilization and the rule of law, becoming the first dragonlord. His reign was peaceful and just until his evil brother, Nicol Bolas, destroyed his hopes for a harmonious civilization. Moved to war, Arcades built a grand army to oppose his brother's plans for world domination. Arcades survived Bolas's onslaught and was one of the handful of dragons to survive the Elder Dragon War. He met his end in a duel between planeswalkers millennia later.

▲ **Arcades, the Strategist** 🖌 **Even Amundsen**

Vaevictis Asmadi

The vain and mercurial Vaevictis Asmadi embodied the cruelty of dragonkind. Where the others of his kind had grand designs for Dominaria, Vaevictis was content to be a bully, dominating lesser dragons to satisfy his own ego. His pettiness would be his undoing, as he enraged the young Nicol Bolas, who schemed to defeat the larger and more powerful dragon. Before Vaevictis could react, Bolas and his human army slew the great bully's minions. Vaevictis's greed put him at odds with the even more vicious Palladia-Mors, who ultimately destroyed him.

▲ **Vaevictis Asmadi, the Dire** ▰ Steven Belledin

Palladia-Mors

Palladia-Mors was every bit as brilliant as her draconic brethren, but where her brothers plotted and schemed, Palladia wished only for the thrill of the hunt. Palladia-Mors embodies the primal, bestial urges of dragonkind. While she, too, was embroiled in the Elder Dragon War, her fate would not be sealed until long after the bloody conflict. Her bloody rage at humanity put her in opposition to her brother Chromium, who was forced to kill her to stop her rampage.

▲ **Palladia-Mors, the Ruiner** ↜ Svetlin Velinov

Chromium Rhuell

The most enigmatic of the elder dragons, Chromium Rhuell merely wanted to observe and learn about the world upon which he had been born. After his mate was slain by the wielder of the Blackblade, a sword of ancient evil, Chromium devoted more and more of his time to studying humanity. His observations ultimately led to a strong empathy for humans, which frequently put him at odds with the rest of his kind. His empathy would ultimately be his undoing, and he was slain defending his young human friend.

Nicol Bolas

Nicol Bolas's destiny was shaped the day of his birth. Trapped and helpless, he witnessed the death of his sister at the hands of human hunters. Bolas became obsessed with power, and this obsession led him to wage war on his fellow elder dragons until his own planeswalker spark ignited. With every plane at his disposal, Bolas set about to subjugate the Multiverse as its rightful God-Emperor.

Bolas lost his godhood as the result of an event known as the Mending, when the nature of the planeswalker spark changed to save the Multiverse from cataclysm, and he would stop at nothing to get it back. The elder dragon ravaged planes to find the pieces he needed for his grand plan for re-ascension. At the cusp of victory, he was robbed of his spark and imprisoned by his twin, the spirit dragon Ugin.

▲ **Nicol Bolas, the Ravager** ◌ **Svetlin Velinov**

Darigaaz

Darigaaz is the primeval embodiment of draconic rebirth on the plane of Dominaria. Reincarnated upon his death, Darigaaz has lived many lifetimes and will live many more. Darigaaz strives to avoid the mistakes of his past, when his primeval siblings had attempted to subjugate the world under dragonkind. Now he is a leader among his kind, persuading the dragon nations toward peace and prosperity by cooperation with humanity.

◄ **Darigaaz Reincarnated** ► Grezegorz Rutkowski

▲ **Primeval's Glorious Rebirth** ► Noah Bradley

Yawgmoth

The most pervasive evil in the Multiverse began with one man. Yawgmoth was a healer, but the cruel and self-centered physician used his skills to further his own power, being hailed as a hero for curing diseases he himself had created and spread. Upon the discovery of the artificial plane of Phyrexia, Yawgmoth lured his people into following him.

Yawgmoth spent ages shaping himself into a god and twisting his people through genetic engineering and artifice. Only the millennia-long efforts of the planeswalker Urza stymied his invasion of the plane of Dominaria, but the ancient evil Yawgmoth had created lived on past his death.

▲ **Yawgmoth's Vile Offering** ✍ Noah Bradley

▸ **Yawgmoth, Thran Physician** ✍ Mark Winters

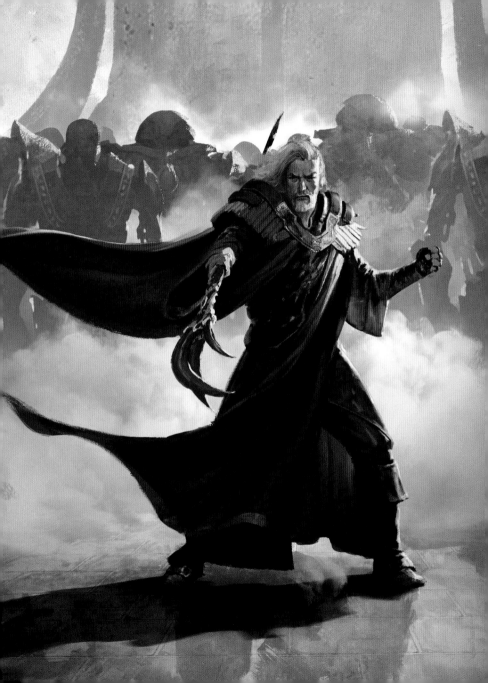

Urza

Few beings are more infamous in the Multiverse than the planeswalker Urza, whose brilliance was matched only by his arrogance. In his youth, his haughtiness led to a rift with his brother Mishra. Their feud led to decades of war that devastated a continent, until Urza discovered their war was being influenced by the twisted Phyrexians. Urza unleashed a cataclysmic blast, ascending as a planeswalker in the process but killing his brother. Urza's grief over Mishra and rage at Phyrexia defined a millennia-long crusade.

Urza built the Tolarian Academy to research new weapons for the coming war against Phyrexia. His insensitivity pushed away friends and allies, as nothing mattered more to him than victory. To achieve it, Urza was willing to pay any price—including his own life. As Phyrexia's vile leader, Yawgmoth, manifested upon Dominaria, Urza sacrificed himself to destroy the would-be god.

◄ **Urza, Lord High Artificer** ✍ Grezegorz Rutkowski

▲ **Urza's Rage** ✍ Jim Murray

Jodah

Jodah is a descendant of the planeswalker Urza. While his brilliance is equal to his infamous ancestor's, Jodah's life has been tempered by the humanity his fore-bear lacked. A chance encounter with a fountain of youth while escaping roving gangs of goblins granted Jodah eternal life. As he mastered the ways of magic and began teaching it to others, Jodah became known as the Archmage Eternal. His many deeds have faded into myth, leading to confused historians speculating on how one man could have accomplished so much.

Over the millennia, Jodah has alternated between being a nation-building hero and a simple mentor and teacher. Ages after his birth, having saved the world on more than one occasion, Jodah continues to teach the ways of magic to young minds across the plane of Dominaria. To save the world, Jodah reminds his students, one must not forget the people who make it worth saving.

Jodah, Archmage Eternal ◊ Yongjae Choi

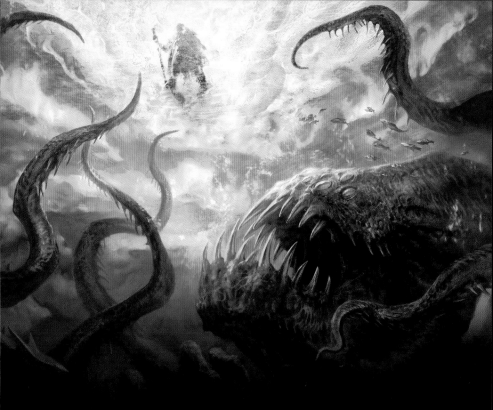

Marit Lage

Marit Lage lies dreaming deep beneath the ice of Dominaria. This ancient being of cosmic power came to the plane of Dominaria long ago and was bound within a glacier's heart, but even trapped beneath the ice her influence spreads. Cultists in pursuit of power whisper arcane secrets about their dread mistress, doing her bidding as she slumbers. Her dreams manifest on the waking world. If the day comes when she is finally loosed from her prison, the plane itself will quake before her power.

▲ **Dark Depths** ⬚ Mathias Kollros

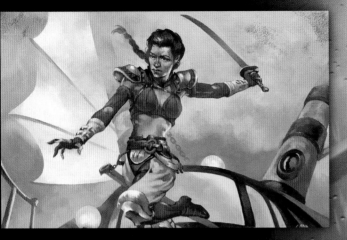

Sisay

The swashbuckling skyship captain Sisay built a ragtag crew to defend her plane from invasion. Orphaned from a young age, Sisay's only inheritance from her family was the flying ship *Weatherlight*. Tracking down the mystery of the ship led her to the ancient conflict between Urza and Phyrexia. With Sisay at the helm, the *Weatherlight* became a symbol of hope to a world at war.

Sisay and the *Weatherlight* led the charge against the Phyrexian Invasion. Just as all seemed lost, her stalwart skyship unleashed Urza's final desperate gambit, a weapon capable of destroying Phyrexia. The *Weatherlight* was lost beneath the sea in the blast, but Sisay and her crew were victorious. A grateful plane rewarded her with a new ship, and together with her surviving crew they took to adventure once more.

▲ **Captain Sisay** ⬎ Ray Lago

▶ **Sisay, Weatherlight Captain** ⬎ Anna Steinbauer

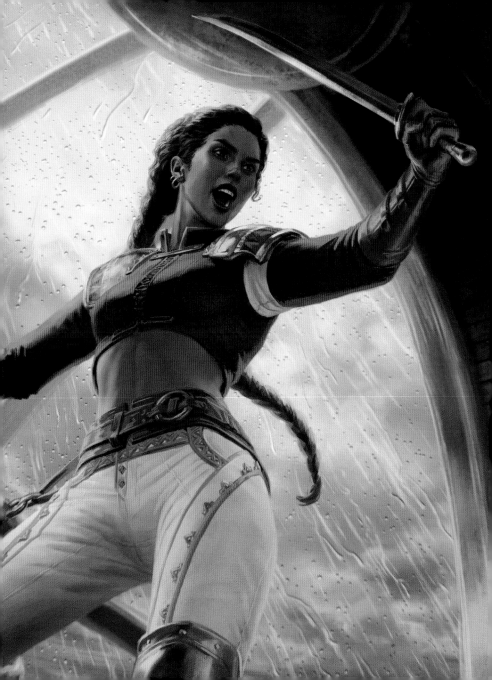

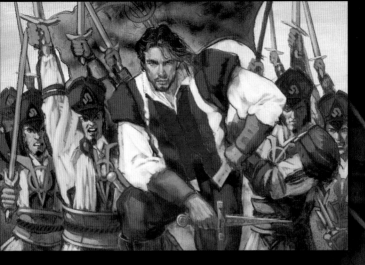

Gerrard Capashen

The noble young Gerrard Capashen joined the crew of the skyship
Weatherlight in an effort to discover the secrets of his past. Valiant and
daring, Gerrard was always at the front lines, leading the crew into battle.
As the *Weatherlight* discovered Phyrexia's plans for Dominaria, Gerrard
learned the haunting truth: he was engineered by the planeswalker Urza
to be the perfect soldier to lead his ancient war against Phyrexia.

When Gerrard rejected a deal from Phyrexia's dark god, Yawgmoth,
he turned to the last remaining hope for his plane: a weapon of terrible
power with a great cost. To save his world from destruction and defeat
Yawgmoth, Gerrard sacrificed himself. Centuries later, he is honored and
hailed as one of the greatest heroes his plane has ever produced, his
courage an inspiration for every generation that followed.

- ▲ **Charisma** ⬿ Terese Nielsen
- ▸ **Gerrard, Weatherlight Hero** ⬿ Zack Stella

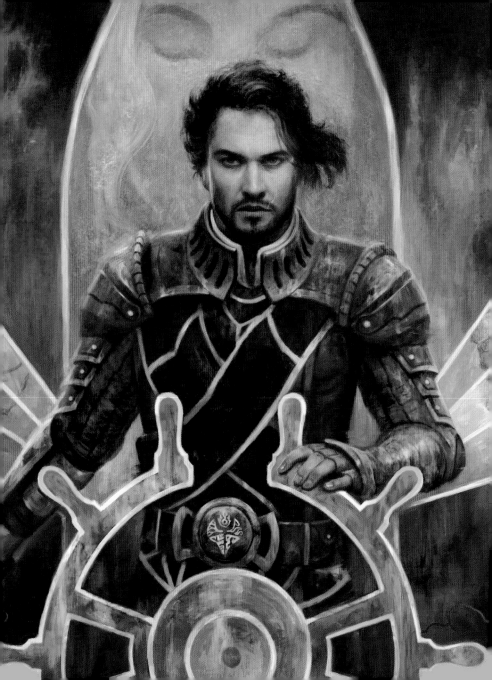

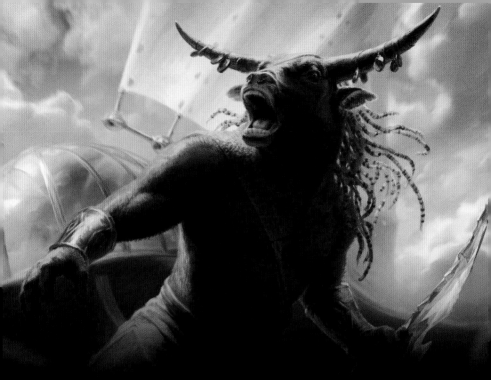

Tahngarth

Tahngarth was a minotaur who served as first mate aboard the skyship *Weather-light*. Fiercely loyal but quick to anger, Tahngarth was always the first crew member into battle. The brave warrior was captured and tortured by Phyrexia, his body modified into a monstrous hulk. He was rescued by his crewmates before his mind could be twisted against them.

 Tahngarth lost his homeland during the ensuing war with Phyrexia, but despite his losses he remained steadfast in the face of looming apocalypse. If the end were to come, Tahngarth believed, he would meet it horns-forward, charging into the face of certain death. Tahngarth's legacy was one of nobility and valor shining through a monstrous exterior.

▲ **Tahngarth, First Mate** ◇ **Anna Steinbauer**

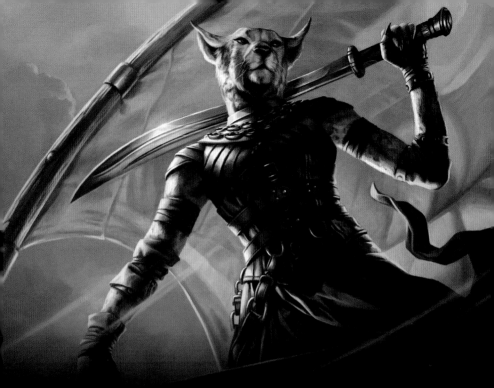

Mirri

The leonin warrior Mirri was an inseparable companion of the hero Gerrard Capashen. She trained alongside Gerrard, and together they joined the crew of the miraculous skyship *Weatherlight*. As steadfast as she was ferocious, Mirri's lithe combat techniques quickly dispatched the crew's foes.

When the *Weatherlight* faced deadly peril, trapped in the grasp of the evil Phyrexia, Mirri sacrificed herself to buy the time the ship needed to escape. To Mirri, hesitation was worse than death. There was no regret to be had in a life well-lived, or one spent saving those she cared about.

Mirri, Weatherlight Duelist Magali Villeneuve

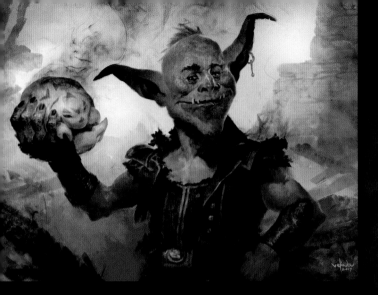

Squee

The goblin Squee was once a member of the crew of the legendary skyship *Weatherlight*. His youth and lack of discernible skills led him to the role of cabin boy. These traits didn't stop Squee from evolving into a hero who always protects his friends. His tragic death was cut short by the magic of the dark god Yawgmoth, whose resurrection spell worked a little too well.

Centuries later, Squee is eternally unable to die—or at least to stay dead. The extreme boundaries of this mysterious power have yet to be tested, but being unable to be killed for good has left the diminutive goblin with little to fear and even less reason to develop more sense

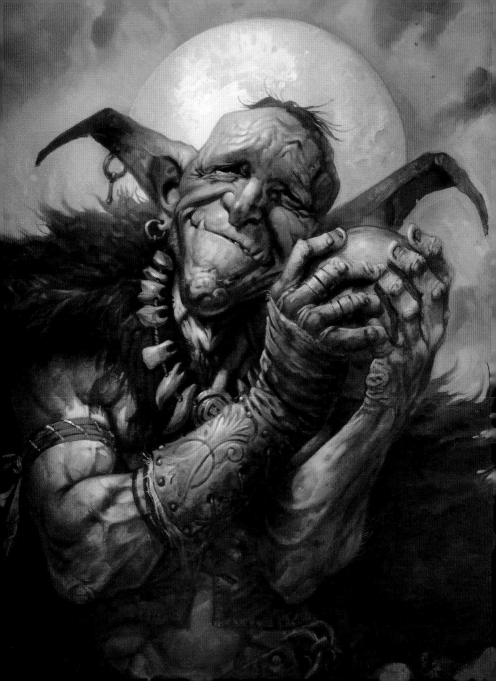

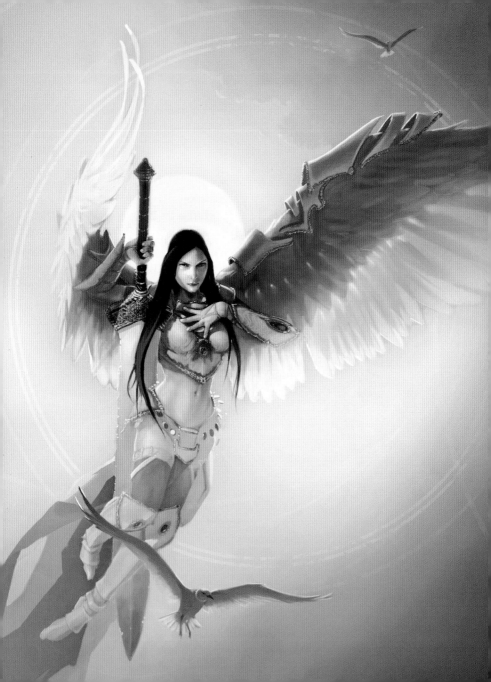

Akroma

The warrior angel Akroma is unique among the angels of the Multiverse. She was originally created by the illusionist Ixidor in the image of his dead love, slain by the evil organization known as the Cabal. Upon Ixidor's death, Akroma founded a religion devoted to him, drawing people from across the plane into her service. Akroma waged war against the Cabal and finally tracked down her creator's murderer.

In a bizarre confluence, Akroma and the killer were merged into a single magical being, a false god called Karona, who terrorized the plane Akroma had sought to protect. When the god was defeated, Akroma did not return, although her people have memorialized her as a symbol of righteous vengeance.

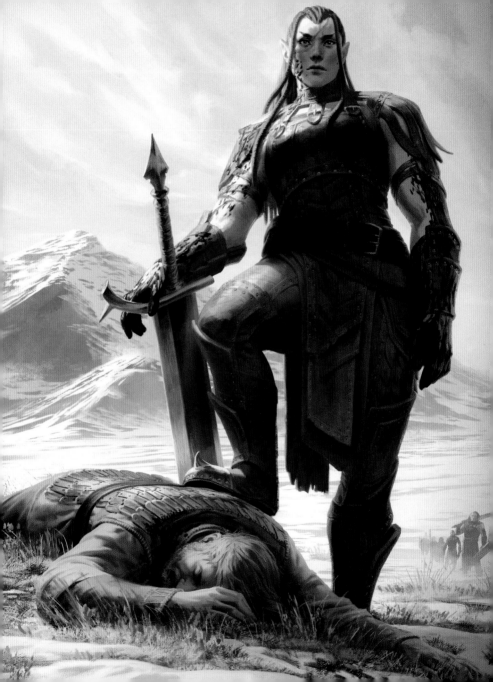

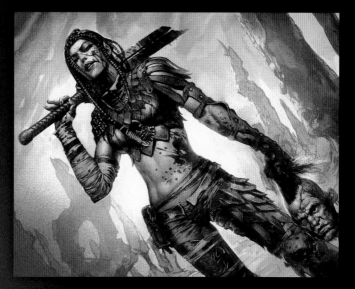

Radha

Descended from both the elves of the forest and the ferocious Keldon barbarians of the mountains, Radha is a woman of two worlds. From a young age, she rebelled against the elvish ways, instead training to one day become a barbarian warlord. Radha's heart was divided, and it was not until she embraced both aspects of herself that she grew to become the leader both her peoples needed. Since then, she has spent decades forging her fractured people, elf and Keldon alike, into a single mighty nation. Radha reigns as Grand Warlord, committed to bringing self-sufficiency to a people once known only for plundering.

◀ Grand Warlord Radha 🠖 Anna Steinbauer

▲ Radha, Heir to Keld 🠖 Jim Murray

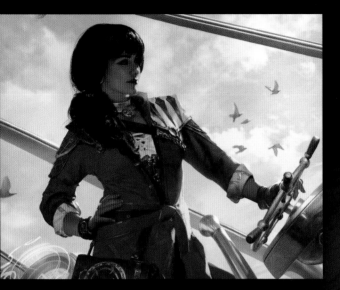

Jhoira

Trapped on her island home after a time travel experiment wreaked chaos, Jhoira's ingenuity helped her survive a grim fate. The experience produced a profound effect on the young woman, effectively granting her eternal youth. Her cunning led her to become the first captain of the skyship *Weatherlight*, saving people across the Multiverse.

 Over a millennium later, Jhoira rebuilt the sunken *Weatherlight* in her quest to stop the villainous Cabal. Together with her crew of legacies and outcasts, she put a halt to the Cabal's rise and continues to hunt down the remaining factions across the plane.

- ▲ Jhoira, Weatherlight Captain ▻ Brad Rigney
- ▸ Jhoira of the Ghitu ▻ Magali Villeneuve

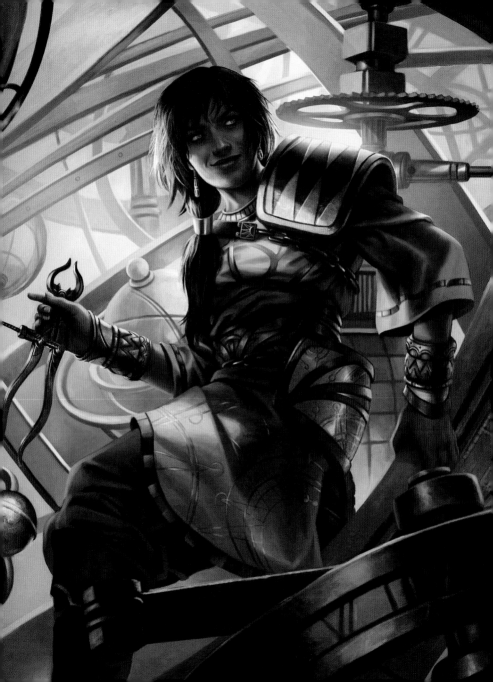

"A problem is only
a problem if you don't
have the tools to
correct it." —Jhoira

UNWIND

▲ Jhoira of the Ghitu ▻ Kev Walker

▸ Board the Weatherlight ▻ Tyler Jacobson

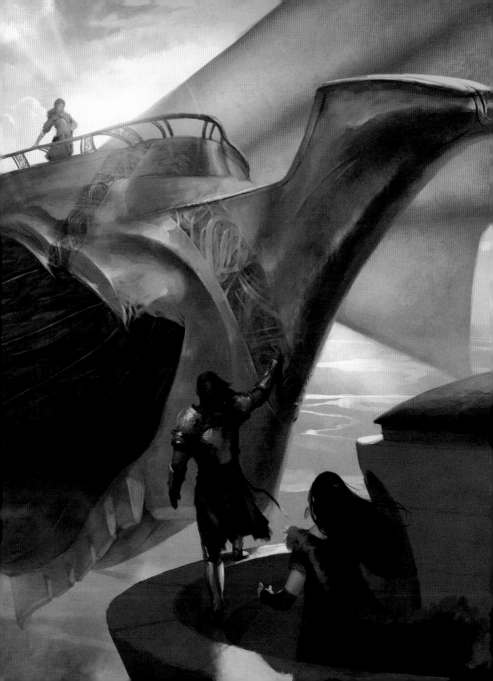

Slimefoot

Millennia ago, to survive an impending ice age, a group of elves bred the fungal beings called thallids for food to survive. They did their work a little too well and were quickly overrun by their creations. Over the centuries these thallids spread across the plane. When the ancient hero Jhoira rebuilt the skyship *Weatherlight*, the wood she used carried those thallid spores. Incubating deep within the engine room, the fungal growth went unnoticed for weeks.

When Slimefoot was finally grown enough to walk on its own, the crew was unsure how to deal with the unusual stowaway. The young thallid clearly viewed the *Weatherlight* as its home. Ultimately, it was adopted as part of the crew, tending to its own crop of fungi aboard the skyship and occasionally helping the crew out of—and sometimes causing—sticky situations.

▲ **Slimefoot, the Stowaway** ▻ Alex Konstad

Yargle

The enormous spirit Yargle skitters across the swamplands of Dominaria, consumed only with a hunger that can never be sated. Birthed by a bizarre sequence of events, the evil sorcerer who would become Yargle was cursed to the form of a maggot for his hubris. The maggot was eaten by a frog, and the sorcerer's dark power twisted the frog's spirit, killing the frog and emerging as a monstrous spectral entity. Since then, Yargle has only continued to grow, and many unwary travelers have found themselves his meal.

▲ **Yargle, Glutton of Urborg** ⋫ Jehan Choo

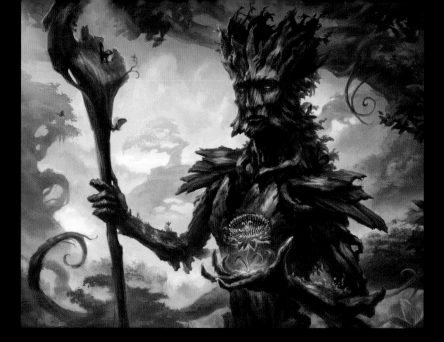

Multani

The most vibrant forests on the plane of Dominaria birth nature spirits, avatars of nature itself, to act as guardians and fulfill their will. In most cases, these elemental beings rarely get involved in the affairs of mortals. For the elemental known as Multani, Phyrexia's unnatural horror represented too great a threat. He allied himself with the planeswalker Urza and was on the front lines of the Phyrexian Invasion. Centuries later, Multani continues to guard his forest home, but his eyes are ever outward, watching for the next threat on the horizon.

▲ **Multani, Yavimaya's Avatar** ➤ Ryan Yee

▸ **Multani concept art** ➤ Tyler Jacobson

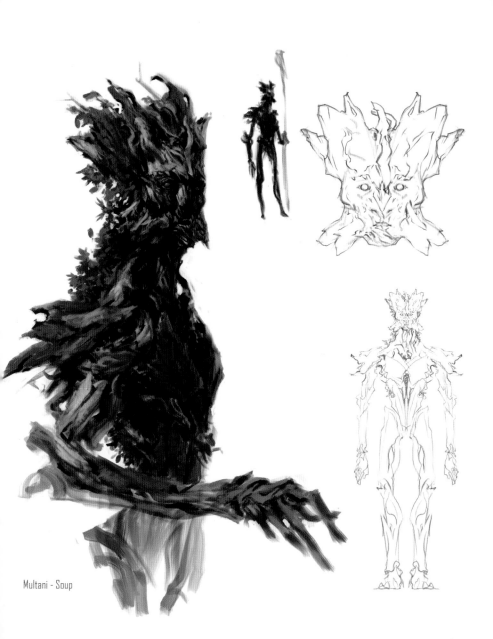

Multani - Soup

"You are not alone. You never were."

LYRA DAWNBRINGER

Lyra Dawnbringer

Across the Multiverse, angels represent hope and salvation. While their origins are often shrouded in mystery, Lyra Dawnbringer knows exactly where she comes from. Born from the last sacrifice of her goddess, Lyra leads the Order of the Dawn, a legacy of the heroic angels who came before. A leader of angels and a force for good on her home plane of Dominaria, Lyra brings salvation for the righteous and divine judgment for the wicked.

Lyra Dawnbringer ✒ **Chris Rahn**

NEW PHYREXIA

When the planeswalker Urza sacrificed himself to defeat Phyrexia, he was unaware that he had sown the seeds of Phyrexia's eventual return. Urza's silver golem, Karn, ascended as a planeswalker in the blast that destroyed Yawgmoth and his forces. As Karn traveled the Multiverse, he unknowingly carried a Phyrexian contagion with him. Karn created Argentum, a perfect metal world populated only by golems.

The Phyrexian oil infected one of those golems, driving him insane and creating an obsession with becoming a planeswalker. The golem named himself Memnarch and pulled creatures from across the Multiverse to populate the metal world he renamed Mirrodin. The Mirrans quickly adjusted to their new world, with metal-like fungal growths adapting them to the hostile environment. In a mysterious event known as the Vanishing, the first generation of Mirrans disappeared, leaving behind bewildered younger generations who had never known another home.

Deep beneath the plane's surface, the Phyrexian oil was growing a new breed of Phyrexian. These New Phyrexians would multiply for decades, abducting Mirrans from the surface to swell their numbers as they prepared for an invasion. Five New Phyrexian factions rose to power, each led by a praetor, a Phyrexian exemplar of that faction. Now only a handful of Mirrans are left to struggle against the rebirth of Phyrexia that has dominated their world.

Norn's Dominion ▷ Igor Kieryluk

Memnarch

Created to watch over the artificial world of Mirrodin, Memnarch was corrupted by the Phyrexian oil accidently brought by his planeswalker creator, Karn. He became obsessed with gaining a planeswalker spark. Using magical machinery, Memnarch summoned living creatures from across the Multiverse to inhabit his metal world. Memnarch believed he had found a spark in the elf warrior Glissa Sunseeker.

Scheming deep within the plane's core, Memnarch played with the surface dwellers like a mad god. His creations slaughtered Glissa's family, driving her to find the being responsible. Memnarch, for all his power, was not a match for the tenacious elf. She destroyed him just as his chance to attain true godhood was within reach.

◄ **Memnarch** ➤ Carl Critchlow

▲ **Aether Vial** ➤ Karl Kopinski

Glissa Sunseeker

On the metallic plane of Mirrodin, Glissa Sunseeker went on a quest for revenge after a mechanical monstrosity slaughtered her family. Although she was a warrior of unparalleled skill, Glissa still found herself marveling at the world outside her forest home. Along the way, she and her allies discovered that deep beneath the surface world was a hollow core. That core was dominated by Memnarch, a golem driven mad by some dark power.

Glissa defeated Memnarch but was captured by the darkness lurking under the surface: New Phyrexia. New Phyrexia had grown in secret, twisted abominations of flesh and metal preparing for conquest in the hidden corners of the plane. Once the plane's hero, Glissa has since been warped and corrupted. Now she serves the praetors of New Phyrexia, dispatching the weak Mirrans she had once sworn to protect.

◄ **Glissa Sunseeker** ➤ **Brom**

▲ **Glissa the Traitor** ➤ **Chris Rahn**

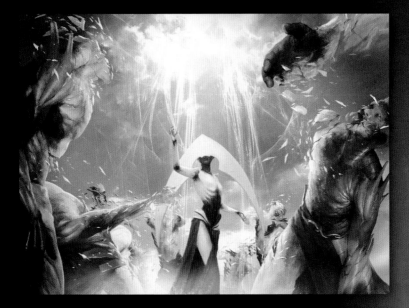

Elesh Norn

Elesh Norn's Machine Orthodoxy believes that flesh is impure and must be excoriated for a being to be made *compleat*, or perfected into a true Phyrexian. Believing that her vision of perfection must be spread, and that which cannot be made perfect must be obliterated, Elesh Norn has risen as the fanatical leader of New Phyrexia. She is now the first among the praetors. Gestating deep within the core of her plane, her invasion of the surface has wiped out almost all the resistance to her reign. Now Elesh Norn seeks to secure that reign and spread the gospel of the Machine Orthodoxy until all of New Phyrexia is remade in her image.

- ▲ **Rout** ✒ Igor Kieryluk
- ▶ **Elesh Norn, Grand Cenobite** ✒ Igor Kieryluk

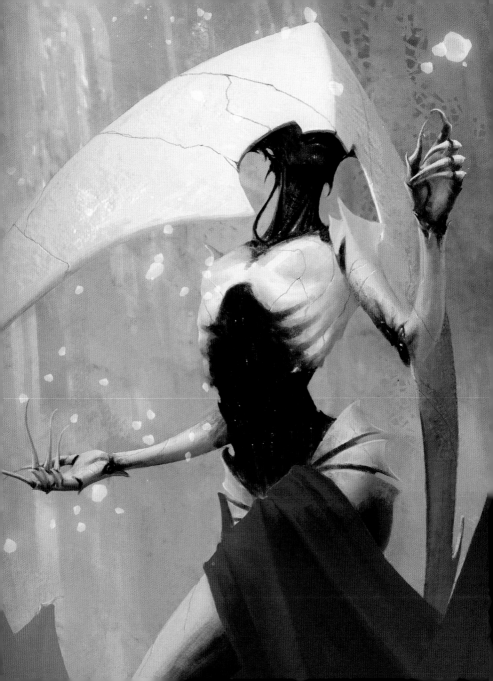

"We are a single entity.
Dissenters must be sutured
into the Orthodoxy."
—Elesh Norn, Grand Cenobite

MARROW SHARDS

Due Respect ❧ James Ryman

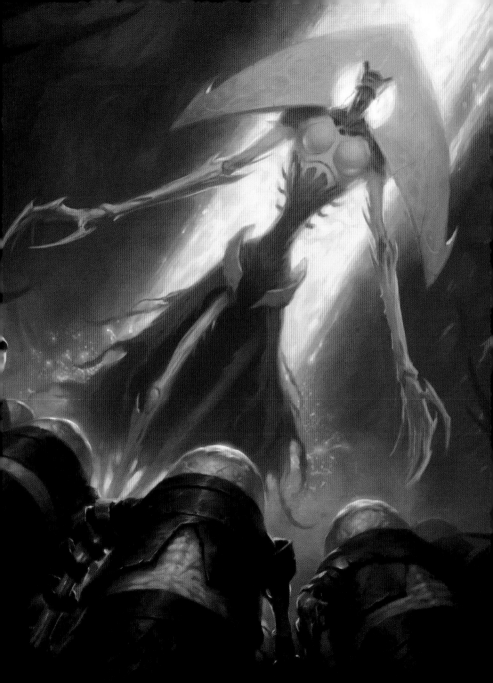

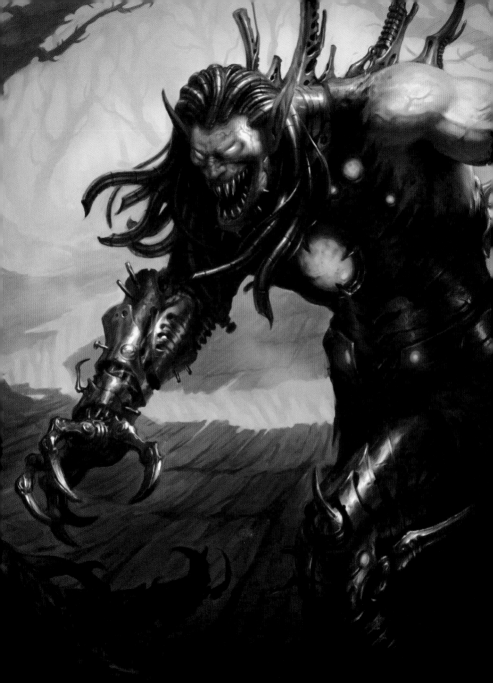

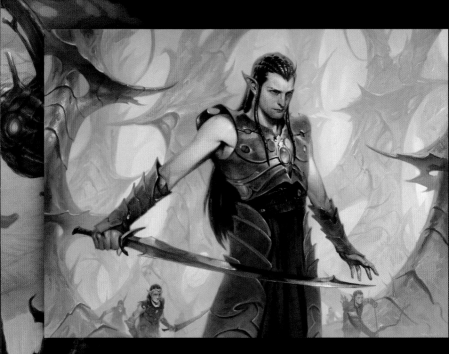

Ezuri

A bandit before New Phyrexia conquered Mirrodin's surface,
Ezuri saw a chance to gain power as a leader of the Mirran
resistance. His mastery of guerilla warfare wasn't enough
to hold off the Phyrexian tide. Ezuri was captured by New
Phyrexia, surgically altered and subjected to the mutagenic

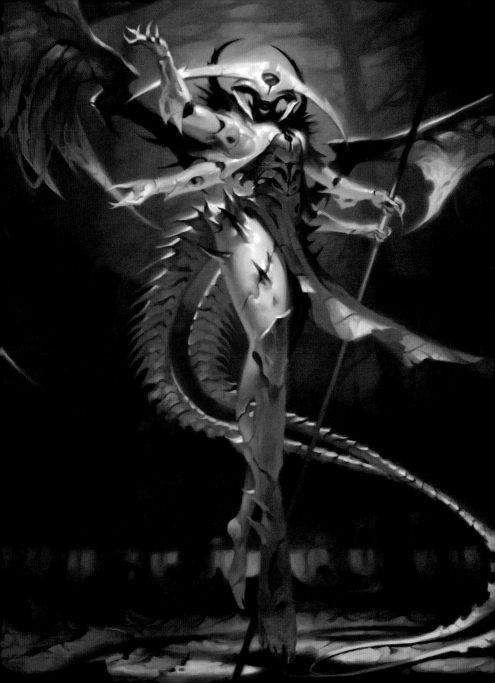

> "Even your blade knows
> who will triumph here."
> —Atraxa, Praetors' Voice

GRIP OF PHYRESIS

Atraxa

The horrific angel Atraxa represents the complete victory of New Phyrexia over Mirrodin. Once a Mirran angel, Atraxa was captured and transformed at the behest of the New Phyrexian leadership. She now serves as a messenger and emissary among the rival factions of New Phyrexia as they inevitably turn against one another with the Mirran threat extinguished.

Atraxa, Praetors' Voice ⤜ Victor Adame Minguez

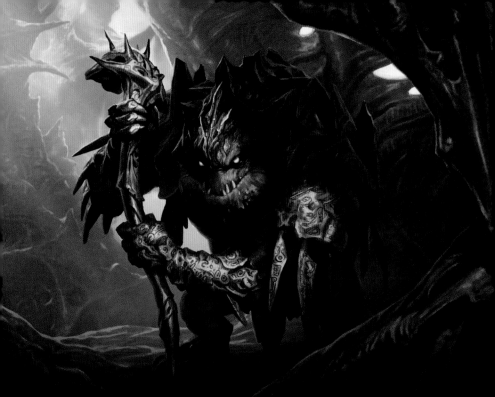

Thrun

When the mad golem Memnarch kidnapped beings from across the Multiverse for his grand experiments, only the trolls recalled that Mirrodin was not the world they once knew. They inscribed the truth on their metal trees, but with no way to return home, they remained silent rather than upset the new order of the plane.

Their silence would prove their undoing, as only Thrun remained after Memnarch's defeat. When Thrun stumbled across the infant Melira, exiled for her immunity to the metallic fungal growths endemic to Mirrodin, he raised her as his own. Now Thrun's choice to rescue Melira is Mirrodin's only remaining hope, as the young girl's immunity is the only thing keeping the surviving Mirrans alive.

▲ **Thrun, the Last Troll** ❧ Jason Chan

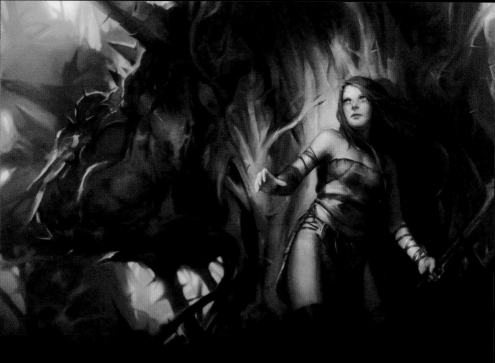

Melira

The salvation of Mirrodin was initially considered a freak by her people, born with an immunity to the metallic fungus ubiquitous to the plane. This immunity rendered her an outcast, and she was shunned. Melira was found and raised by a troll named Thrun, and kept safe in the harsh metal forests of Mirrodin.

 When the twisted New Phyrexians began their campaign of conquest, Melira was captured and studied for her immunity. They discovered her immunity extended to the Phyrexian oil used to transform the people of Mirrodin. Before they could dispose of Melira, she escaped their grasp and fled to the Mirran resistance. Granted the ability to spread her immunity, the outsider Melira is now the Mirrans' best chance to survive.

▲ **Melira, Sylvok Outcast** ⬿ Min Yum

ALARA

The world of Alara was once sundered into five shards by an ancient planeswalker. As the plane was split, the archangel Asha banished the demon Malfegor at the cost of her own life. Each shard was bereft of two of the five colors of mana, and over the centuries each developed a uniquely divergent culture and ecology. The five shards became known as Bant, Naya, Jund, Grixis, and Esper.

The shard of Bant became a tranquil place of honorable combat, overseen by benevolent angels. Naya was a shard of unfettered growth, where enormous beasts known as the gargantuans dominate the lush jungle. Jund was a harsh volcanic landscape where dragons ruled as apex predators. Grixis became a grotesque landscape of undeath where life could barely cling. Esper's geometrically perfect shard became obsessed with enhancing themselves through the magical metal known as etherium.

The five shards were reunited in an event known as the Conflux. The evil planeswalker Nicol Bolas planned to consume the power spawned by this reunion and sent agents to stoke the flames of war. With Bolas long gone, the five shards must now find a way to coexist after eons apart.

Maelstrom Nexus 🪶 **Steven Belledin**

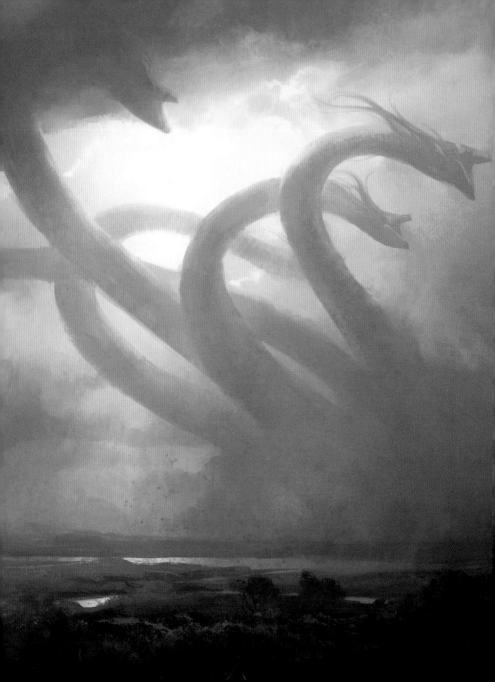

Progenitus

The hydra-god Progenitus is a being of unparalleled power on the plane of Alara. Progenitus's awesome presence inspires worship and fear in equal measure. So powerful is he that the elves of his native forest speak myths of how the giant beasts of the forests were spawned by his might. His visage dominates the horizon, and his heads represent the power of the five colors of magic that flow through him freely. In him, the majesty and awe of nature is made manifest.

◄ **Progenitus** ⬃ Jaime Jones
▲ **Progenitus** ⬃ Mike Bierek

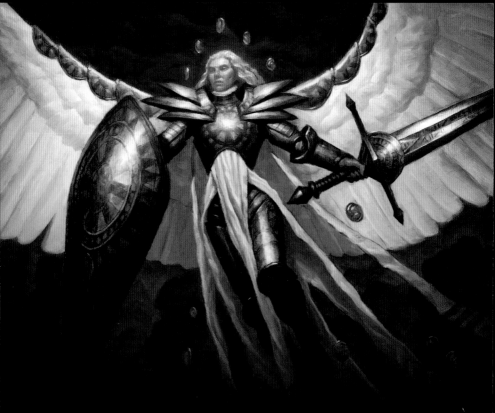

Jenara

Millennia ago, before the plane of Alara was split into five shards, the archangel Asha sacrificed her life to cast out the demonic hordes. Since then, the seven holy Asura have ruled the angels. Jenara, the Asura of War and Strife became the most prominent during the reunion of the shards, leading the angelic host into battle against the evil hordes of Grixis. As the knights of Bant fought heroically against the undead hordes below, Jenara led the angelic hosts to battle demons in the sky.

▲ **Jenara, Asura of War** ⊷ **Chris Rahn**

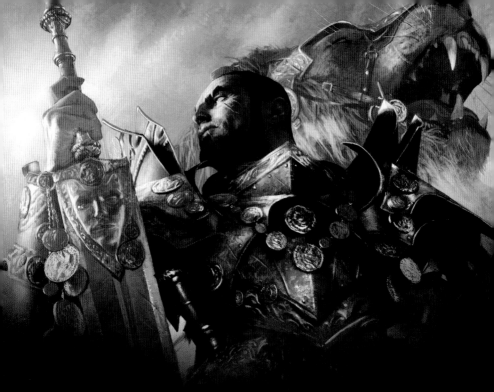

Rafiq

Few knights of Alara have earned as many hallowed sigils, magically empowered symbols of virtue and valor, as Rafiq. The heroic warrior is so adorned with sigils, he has become known as Rafiq of the Many. The martial paragon was nevertheless unprepared for the terror that would come when his once idyllic world was merged with the strange and horrific.

While a master of honorable combat, Rafiq had a steep learning curve for the realities of war that were to come. He took the harsh lessons and, with the help of his allies, Rafiq slew the evil overlord Malfegor. With the armies of Bant at his back, Rafiq turned back the hordes of the undead.

▲ **Rafiq of the Many** ▷ Michael Komarck

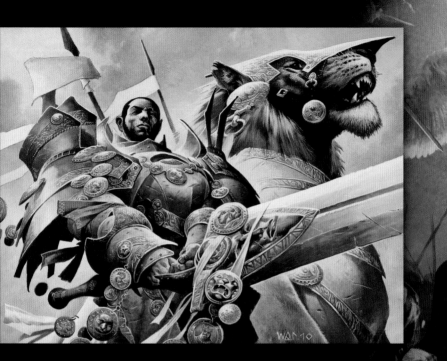

"Many sigils, one purpose."

RAFIQ OF THE MANY

▲ Rafiq of the Many ▷ Wayne Reynolds

▶ Finest Hour ▷ Michael Komarck

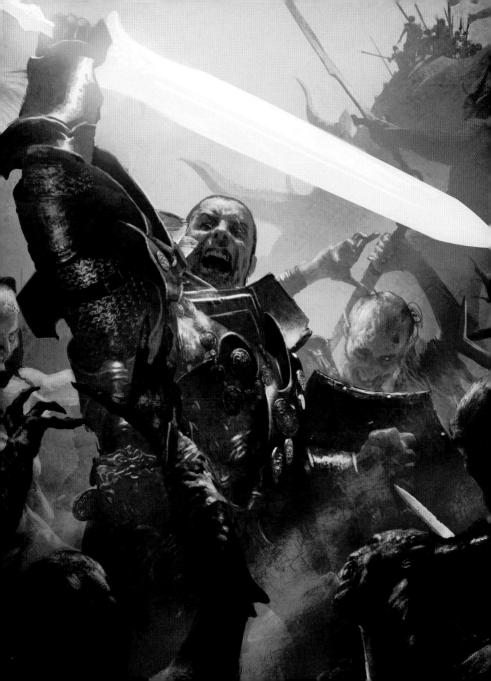

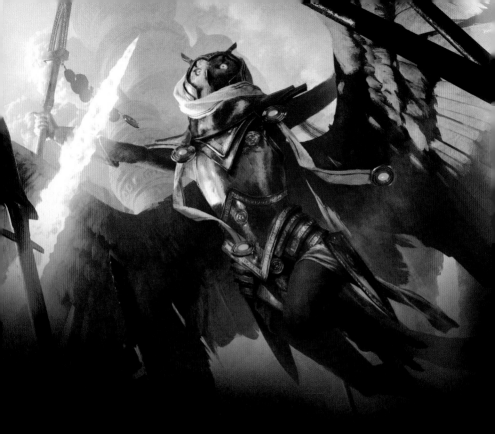

Derevi

The aven savant Derevi is known as the greatest general Alara has ever seen, and for good reason. Above the battlefield, her sharp eyes and cunning wit allow her to quickly maneuver her troops or respond directly when her lines falter. Off the battlefield, her keen intellect has allowed her to negotiate her way out of being assassinated on more than one occasion.

▲ Derevi, Empyrial Tactician ◇ Michael Komarck

Mayael

Mayael is the Anima, the leader of the elves of Alara, who revere the giant
beasts of their forest home as gods. Blinded in the ritual that made her Anima,
Mayael was gifted with magical abilities and an innate connection to nature.
None have more sway over the gargantuans of the forest than Mayael, although
she wishes only to fulfill the will of nature. Under her leadership, the elves live
in peace and prosperity.

▲ **Mayael the Anima** ✍ Jason Chan

Sharuum

The queen of her metal-infused realm of Esper, Sharuum rules from a distance, content to allow her subjects a strong degree of self-determination. When Sharuum deigns to weigh in on matters legal or philosophical, her word is undisputed. Sharuum has led her people through the eons, since her mate, the planeswalker Crucius, disappeared.

Crucius seeded the plane with the magical metal etherium, but he—and the secret of etherium—were lost long ago. Despite her apparent apathy, Sharuum would stop at nothing for another moment with her lost love. With her home reunited with greater Alara, it's unclear how Sharuum will lead her people into the future. Will she be content to rule from afar, guiding her people in the correct direction, or will she take a more direct approach as Esper's way of life is threatened?

▲ **Sharuum the Hegemon** ◗ Izzy

Breya

The hot-tempered young wizard Breya was an etherium sculptor of great skill, blending the delicate-looking metal with living flesh. Following the reunion of Alara, many mages of Breya's homeland journeyed to wider Alara to discover the secret of this magical metal. Not one to be left out, Breya set out on her own journey.

Trusting her instincts over her intellect, Breya journeyed deep within dragon-infested jungle caves on Jund. There, she discovered the legendary missing ingredient, the key to making new etherium. Returning with her discovery, Breya is the first to have created new etherium in centuries, perhaps millennia. Armed with a fortune's worth of the once-rare metal, the world is Breya's for the taking.

▲ **Breya, Etherium Shaper** ▰ **Clint Cearley**

Meren

Meren's primal and violent home of Jund was known for its shamans and the elemental magic they wielded. This magic was often the only thing that could help her clan survive by keeping dragons from preying on the relatively weak humans. Training to become a shaman was harsh, and failure meant death.

Meren was one such failure, but she managed to use her latent necromantic gifts to stave off the ritual poisoning she had been forced to undergo. After journeying abroad, Meren mastered her powers. With the might of undead dragons behind her, Meren avenged herself on her old clan and, shortly thereafter, the rest of Jund.

▲ **Meren of Clan Nel Toth** ☞ **Mark Winters**

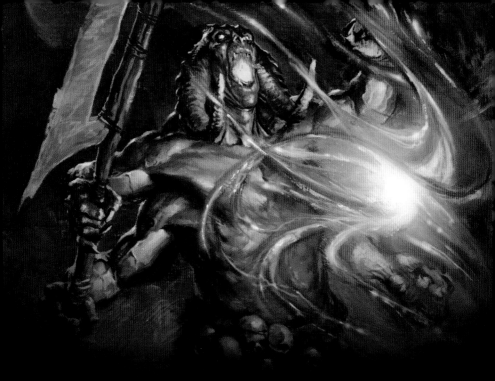

Yidris

Among the ogres of Grixis are the Incurables, beings cursed with unstable muta-
tions. Yidris, a powerful wizard in his own right, was nonetheless unable to cure
his affliction . . . until the day the five divergent shards of his plane become one
again in the Conflux. For the first time in millennia, there was hope of a cure.
Ravaging the world in search of such a cure, he was hounded by knights of Bant
and forced into the Maelstrom, a storm of chaotic magical power formed from
the reunion of the shards.

Left for dead by the knights, the Maelstrom's power healed Yidris, and its
chaotic energies suffused the reborn ogre. Now Yidris acts as a conduit for the
Maelstrom's chaos, sowing discord wherever he travels.

▲ **Yidris, Maelstrom Wielder** ✒ **Karl Kopinski**

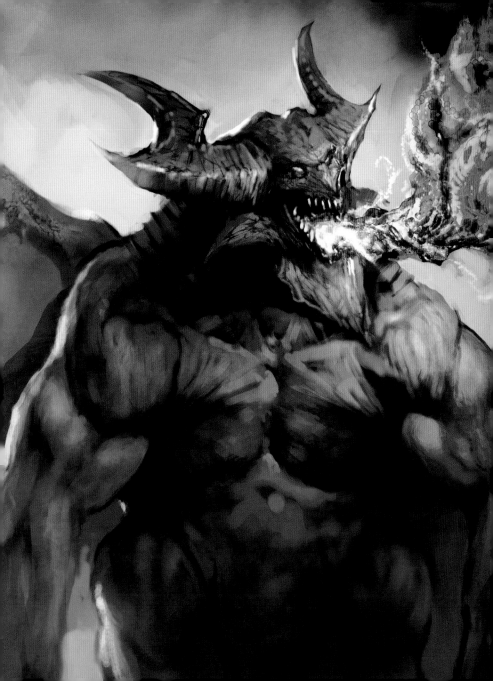

Malfegor

The unholy Malfegor was an abomination created in the plane of Alara's ancient past, a union of the worst of dragon- and demonkind. When the world was split into five shards, Malfegor was trapped on Grixis, the shard of death and decay. Malfegor burns with hatred for Asha, the archangel who imprisoned him.

After languishing for eons, Malfegor was surprised to find a visitor, the elder dragon Nicol Bolas, who told him the five shards would soon be reunited, and he must lead his armies against the rest of the world. However, Malfegor did not count on Asha's holy blade being reforged by a worthy mortal. The demonic dragon was slain at the hands of Rafiq of the Many wielding the blade's divine might.

◄ **Breath of Malfegor** ► Vance Kovacs

▲ **Malfegor** ► Karl Kopinski

ZENDIKAR

Six thousand years ago, three planeswalkers came together to imprison the eldritch beings known as the Eldrazi. The Eldrazi were wreaking havoc in the Multiverse, consuming and destroying planes. Ugin, the spirit dragon, the vampire Sorin Markov, and Nahiri the lithomancer spent decades constructing a hedron network across the plane of Zendikar. When it was finished, they lured the three Eldrazi titans and sealed them away. Their work finished, Nahiri remained behind to guard the prison, unaware of just how much she had changed her home plane forever.

The plane violently rejected the Eldrazi's presence, unleashing waves of cataclysms known as the Roil. The Roil made permanent settlements almost impossible, and the people of Zendikar became largely nomadic. Entire civilizations crumbled and were lost, and ancient treasures and knowledge were trapped in ruins accessible by only the most skilled adventurers.

Over the millennia, warnings about the Eldrazi became myths and the foundation of new faiths. Cultists attempted to free their Eldrazi idols, but Nahiri always stopped them. When the other planeswalkers did not return to aid her, Nahiri disappeared, seeking them out. In her absence, the Eldrazi's prison was broken when the keystone was shattered. The people of Zendikar banded together against the Eldrazi threat, and with the help of an intrepid group of planeswalkers called the Gatewatch, the Eldrazi were exterminated.

Forest ↦ Sam Burley

Ulamog, the Ceaseless Hunger ▸ Michael Komarck

Ulamog

A being of the chaotic space between planes known as the Blind Eternities, Ulamog's purpose is as inscrutable as it is destructive. Bound by a trio of planeswalkers to the plane of Zendikar, upon his release Ulamog began consuming the plane by draining it of its magical lifeblood: mana. All that was left in his wake were wastelands of dust. What purpose this served, whether to sate eldritch hunger or as some part of a horrific cosmic life cycle, mattered little to the beings turned to ash by his presence. All that is known is that when Ulamog was sated, nothing would be left of a plane, and the fabric of reality itself would crumble and collapse.

▲ **Ulamog concept art** ✒ Sam Burley

Kozilek

A being from the abstract space between dimensions called the Blind Eternities, the laws of reality warp and contort at Kozilek's passing. Time and space are nothing to Kozilek, and once freed from his bondage on the plane of Zendikar, his presence left only a bizarre reshaping of the landscape as a clue to his ineffable purpose. Once worshipped as the Zendikar god of the sea, upon revelation of his true nature, the people of Zendikar fought desperately for survival. The ancient Eldrazi titan was reduced to ash by the intervention of the heroic planeswalkers of the Gatewatch.

▲ **Kozilek, the Great Distortion** ✎ **Aleksi Briclot**

▶ **Kozilek, Butcher of Truth** ✎ **Michael Komarck**

Emrakul

Emrakul, the last and greatest of the interdimensional Eldrazi titans, was known as the benevolent goddess of the wind and sky on Zendikar. In truth, the lingering horror of her terrible visage on the horizon drives most to insanity and despair. Once imprisoned on the plane of Zendikar, she was lured to the plane of Innistrad by the machinations of the mercurial planeswalkers who once bound her. There, her mere presence on the plane produced grotesque mutations.

As Emrakul manifested fully upon Innistrad, even mortal enemies allied themselves against her abominations. The Gatewatch, fresh from their victory over the other Eldrazi titans, attempted to oppose her but lacked the strength to destroy her. Instead, they hatched a plan to imprison Emrakul in Innistrad's silver moon. Thus bound, Emrakul lingers in her prison, awaiting the day she can return.

◄ **Emrakul, the Promised End** ✍ Jaime Jones

▲ **Emrakul, the Aeons Torn** ✍ Mark Tedin

Emrakul, the Aeons Torn ► Vincent Proce

Emrakul Concept Art ⌖ Tyler Jacobson

Omnath

Born of the plane of Zendikar's chaotic mana, the elemental force known as Omnath was imprisoned and bound through a magic ritual. Omnath's prison was deep within Zendikar's wilds, all but unreachable.

When eldritch monstrosities called the Eldrazi were loosed upon Zendikar, the binding circle was broken. Freed from the ancient prison, and embodying not just the plane's primeval power but its rage, Omnath set about unleashing its power on Eldrazi and Zendikari alike.

- ▲ **Omnath, Locus of Rage** ▻ Brad Rigney
- ▶ **Omnath, Locus of Mana** ▻ Mike Bierek

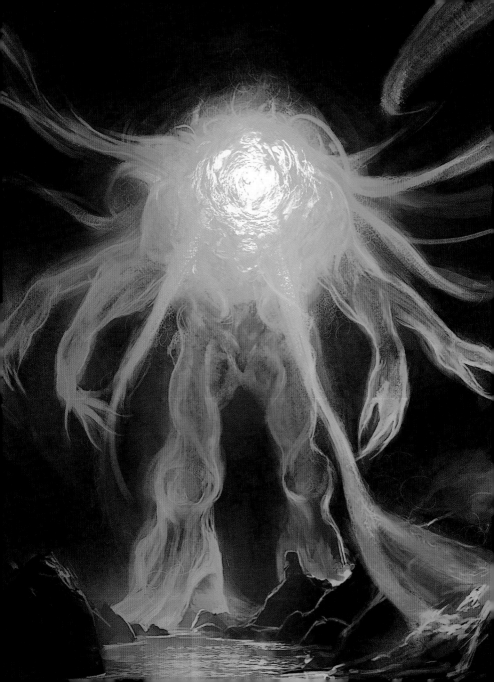

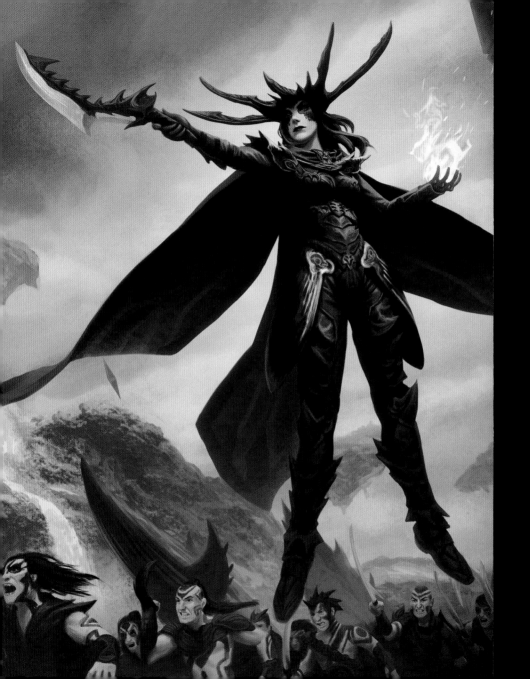

Drana

An ancient vampire of immense power, Drana was once a cultist drawn to the ancient prison of the extradimensional monstrosities, the Eldrazi titans. The titans in their prison were oblivious to the cultists' worship, but the edritch energies seeping out from their prison twisted the cultists into the first vampires of the plane of Zendikar. She lived a hedonistic life for eons as ruler of her own vampiric bloodline, but that all changed when the Eldrazi were finally released from their prison.

The Eldrazi titans attempted to reclaim their ancient vampiric servants and the generations of vampires that followed. Drana was one of the few strong enough to resist their call and led a vampiric rebellion against their former masters alongside the allied forces of Zendikar.

◄ **Drana, Liberator of Malakir** ➤ **Mike Bierek**

▲ **Drana, Ḳalastria Bloodchief** ➤ **Mike Bierek**

Jori En

A relic hunter of great renown, Jori En's forays into the lost civilizations of the plane of Zendikar yielded the key to stopping the extradimensional Eldrazi menace. Her journeys led her through temples submerged deep under Zendikar's waves and into ancient dungeons nestled high in the mountains.

Jori En helped lead a desperate plan to stop the Eldrazi. By reactivating the network of ancient artifacts called hedrons that once bound them, the Gatewatch could create a temporary new prison. The task was easier said than done, and her discoveries led not to the reimprisonment of the eldritch terrors but to their destruction.

- ▲ Jori En, Ruin Diver ⌁ Igor Kieryluk
- ▸ Jori En, Ruin Diver ⌁ Matt Stewart

Tuktuk

The goblin Tuktuk vowed to claim the most impressive, grandest artifact of all time for his tribe. The problem was, Tuktuk wasn't very smart. So when he stumbled across a mysterious stone trap deep within an unexplored dungeon, his first, and technically last, instinct was to touch it.

Lucky for Tuktuk, the magic that suffused the dungeon rebuilt him . . . using the stones he was crushed by. The goblin was reborn as a golem and returned to his tribe. The rest of the tribe was so impressed by his new form, Tuktuk was made chief and ruled his people for decades. That is, until another goblin convinced her tribe that consuming Tuktuk would give them an edge against the Eldrazi. The goblins overthrew Tuktuk and shattered him, consuming the magical stones that were once their leader.

◄ **Tuktuk the Returned** ► Franz Vohwinkel

▲ **Tuktuk the Explorer** ► Volkan Baga

Zendikar's true gods have risen. Whether in reverence or agony, all the world will kneel."
—Ayli, high priest of the Eternal Pilgrims

BLINDING DRONE

Ayli

Ayli was a priestess of the goddess of the wind, Emeria, known as the breath of the world. Ayli believed her god to be beautiful, but her faith—and her mind—was shattered when the extradimensional Eldrazi titans were set free from their prison. Her faith wasn't in a goddess at all, but in the Eldrazi titan known as Emrakul.

Ayli's crisis of faith led to her renewed commitment, to what she believed to be the *true* gods. Believing the end-times to be at hand, Ayli and other pilgrims who shared her vision set out to watch the end of the world, and to sacrifice what was left to their gods.

Ayli, Eternal Pilgrim | Cynthia Sheppard

INNISTRAD

The dark plane of Innistrad is home to all manner of monsters and fiends. Demons strike dark bargains with foolish mortals. Werewolves rage in the night, hunting beasts and humans with equal vigor. Vampires throw elaborate balls in moonlit mansions, feeding on the blood of the innocent. Necromancers raise zombie armies in the hinterlands to follow mad dreams of conquest. Monsters of all shapes and sizes lurk just out of sight, threatening the unwary.

Millennia ago, the nobleman Edgar Markov created the plane's first vampires, including his grandson Sorin Markov. Sorin's planeswalker spark ignited in the process. Sorin's outside perspective made it clear that, left unchecked, vampires would overrun humanity. Sorin knew something needed to be done to rein in his people's gluttonous ways. Expending much of his power on a great enchantment, he created the archangel Avacyn to bring balance to Innistrad.

Centuries after her creation, Avacyn was trapped within the Helvault, a prison made from the plane's unusual silver moon. When she was freed, she soon began to turn on humanity for imagined sins. The planeswalker Nahiri had lured the Eldrazi titan Emrakul to Innistrad in vengeance for an ancient wrong committed by Sorin. Emrakul was stopped, barely, but Sorin was forced to unmake Avacyn in the process. Without Avacyn, can the forces of light keep the night at bay?

Innistrad ☙ **Adam Paquette**

Edgar Markov

Millennia ago, the alchemist Edgar Markov searched for a solution to the famine sweeping across the countryside of his mountainous homeland of Innistrad. Urged by a demon to pursue a more radical course of action, Edgar conducted a blood ritual, exsanguinating an angel and cursing himself in the process. When the ritual was complete, Edgar became the plane's first vampire, the progenitor of his kind.

Edgar would have the others believe he turned to vampirism in desperation. Deep down, however, Edgar simply wanted the power such a dark gift would grant. A minor nobleman as a mortal, Edgar now revels in the grandeur being king of the vampires provides. He gladly will slay anyone or anything that threatens that power, and allow his vampiric minions to feast on them afterward.

◄ **Edgar Markov** ☙ Volkan Baga
▲ **Blood Tribute** ☙ Volkan Baga

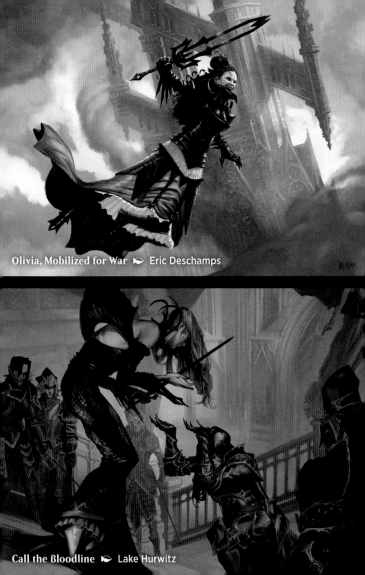

Olivia, Mobilized for War ⮞ Eric Deschamps

Call the Bloodline ⮞ Lake Hurwitz

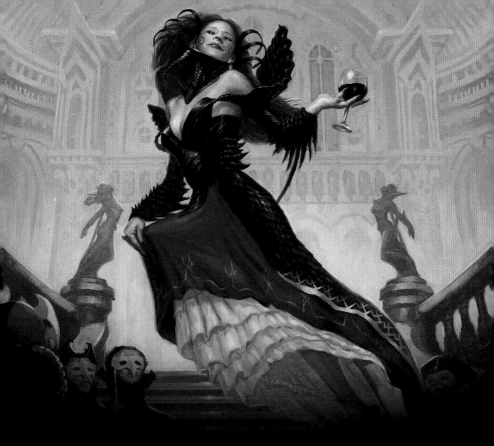

Olivia Voldaren

One of the first vampires turned by the vampiric progenitor, Edgar Markov, Olivia Voldaren's boundless wealth has kept her bloodline strong over the ages. Olivia's taste for the finer things belies a vicious and ruthless nature, and she will do whatever it takes to get what she wants. And she wants everything.

▲ Olivia Voldaren ➤ Eric Deschamps

Avacyn

The archangel Avacyn, created by the planeswalker Sorin Markov, acts as a shepherd for humanity, protecting Sorin's home of Innistrad from interplanar threats, as well as preventing his blood-thirsty vampiric brethren from wiping out humanity. Over the course of a thousand years, the Church of Avacyn stood against the forces of the night. That is, until Avacyn's disappearance sowed the seed of doubt into her church.

Upon her return, she faced Emrakul, an extradimensional being of horrific power. Avacyn was all that stood in Emrakul's way, until she, too, was driven mad by the eldritch presence. Avacyn's creator was forced to unmake her before she slaughtered those she was created to protect.

▲ **Avacyn, Angel of Hope** ✍ Jason Chan

▲ Avacyn, Angel of Hope ✍ Howard Lyon

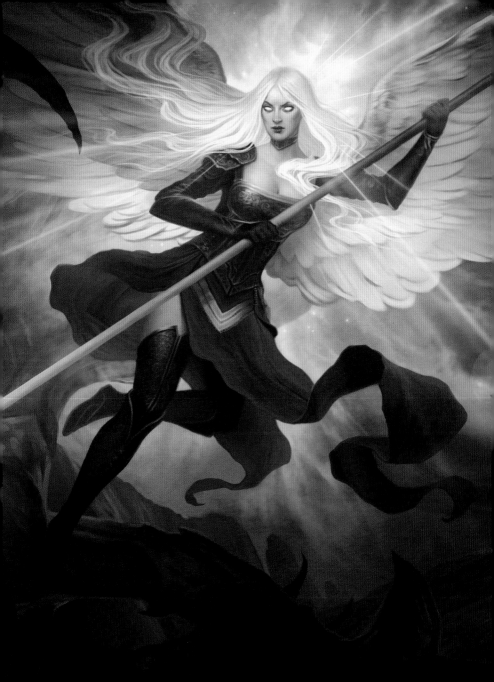

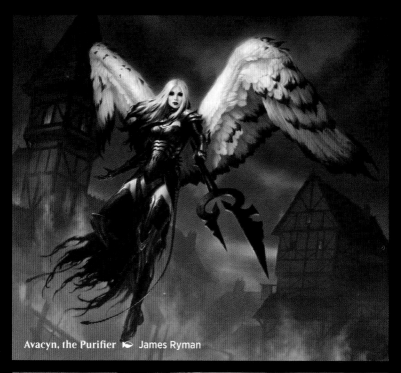

Avacyn, the Purifier ✒ James Ryman

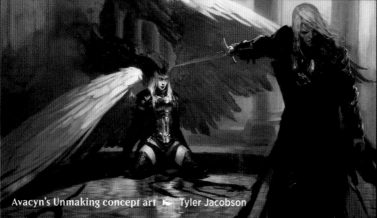

Avacyn's Unmaking concept art ✒ Tyler Jacobson

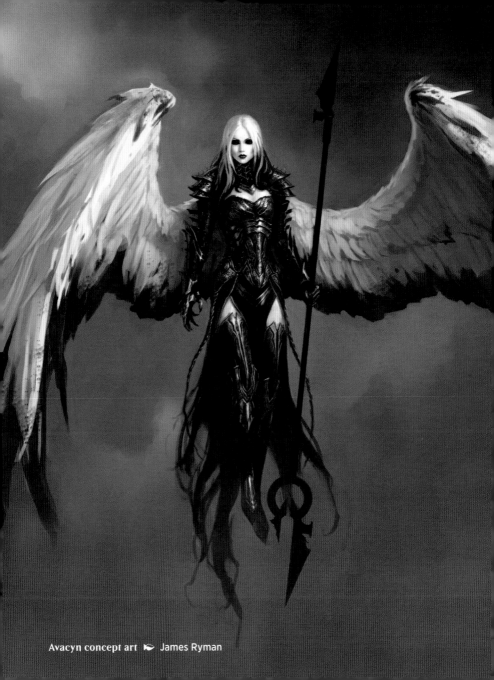

Avacyn concept art ✒ James Ryman

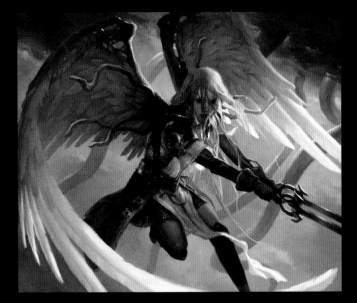

Gisela

One of the ancient angelic protectors of Innistrad, Gisela and her sisters existed long before the appearance of the archangel Avacyn and her church. Finding the church to be the best way to serve humanity, Gisela became a close confidant of Avacyn. Gisela led the battle angels of the church and trained its battle priests to defend humanity.

When Avacyn disappeared, Gisela despaired for humanity. When Avacyn returned, Gisela was the first to succumb to the eldritch corruption that spread from the archangel to the rest of the angels.

◄ Gisela, Blade of Goldnight ▻ Jason Chan

▲ Gisela, the Broken Blade ▻ Clint Cearley

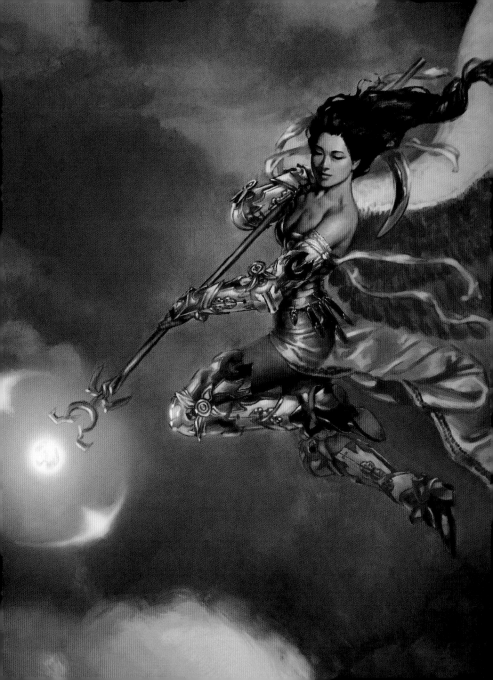

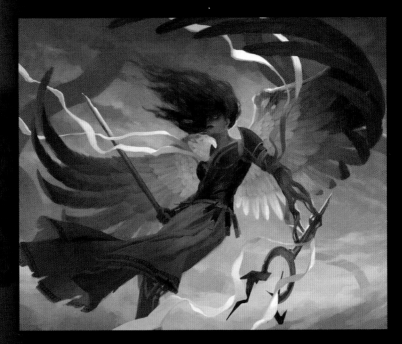

Bruna

Bruna was responsible for ensuring the Blessed Sleep, the great promise to allow human souls and bodies to rest in peace. The Blessed Sleep was the best the angels could promise humanity on a plane where vengeful ghosts are common and necromancy rampant.

Bruna's close connection to the church and her sister, Gisela, led to her falling under the eldritch influence affecting the angels. With Avacyn and Gisela, Bruna turned against humanity. As the purge of humanity for imagined sins began, Bruna and Gisela smiled upon their work. . . .

◄ **Bruna, Light of Alabaster** ✎ Winona Nelson

▲ **Bruna, the Fading Light** ✎ Clint Cearley

Brisela

Bruna and Gisela, once angelic protectors of the plane of Innistrad, were corrupted far more than humanity feared. As the eldritch horror Emrakul manifested fully on their plane, the two angels fused into a single angelic abomination: Brisela.

The newly formed herald of Emrakul, Brisela descended upon the human capital with a horde of Eldrazi mutants to wipe out the last of humanity's resistance. The Eldrazi angel's advance was stopped only through the combined efforts of their sister Sigarda, a saintly spirit, and unwavering heroism.

▲ **Brisela, Voice of Nightmares** ◣ Clint Cearley

▲ **Brisela concept art** ◣ Vincent Proce

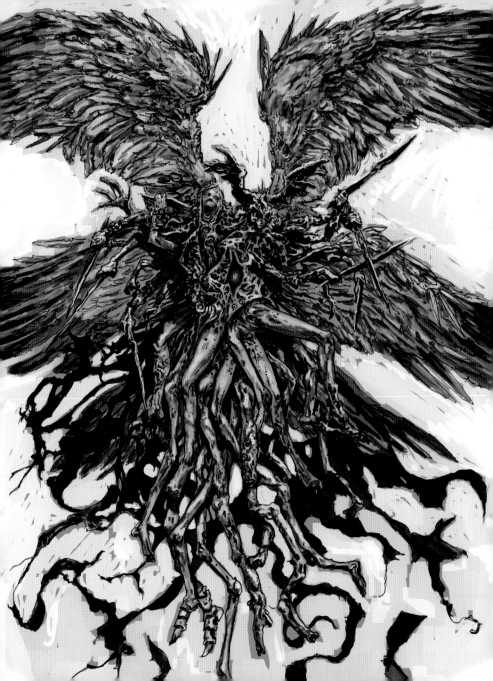

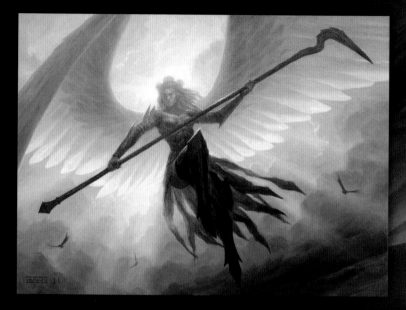

Sigarda

Sigarda long suspected something was amiss with the archangel Avacyn, and her hesitance proved Innistrad's salvation. Working far from the seat of Avacyn's church, the effects of the extra-dimensional monster Emrakul's corruption never reached Sigarda. Sigarda's host represents birth and purity, granting them a resistance to the eldritch influence.

Sigarda's angelic army protected humanity in life, and when the Church of Avacyn fell into disarray, Sigarda stepped up to the people's defense. Humanity has now turned to Sigarda to help lead them out of the dark hours and back into the light.

▲ **Sigarda, Host of Herons** ❧ Chris Rahn
▸ **Sigarda, Heron's Grace** ❧ Chris Rahn

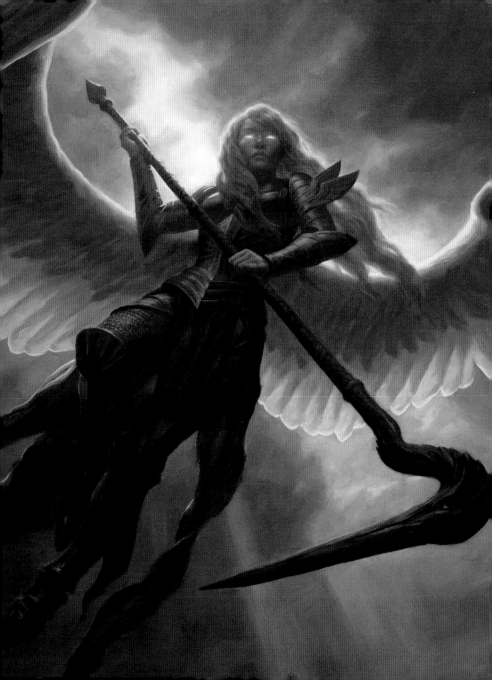

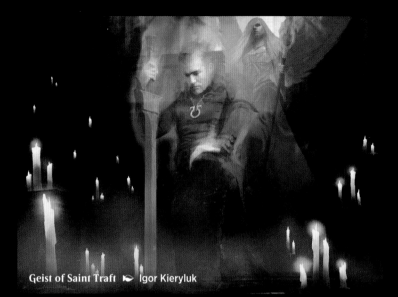

Geist of Saint Traft 🖎 Igor Kieryluk

Geist of Saint Traft 🖎 Daarken

Saint Traft

In life, Saint Traft was a warrior priest, defending the innocent against the forces of darkness. As his fame grew, demon cultists plotted against him, tricking him into murdering innocents before being slain himself. Death was not the end, and Saint Traft's spirit rose again. Motivated by the purity of will he possessed in life, his spirit wandered the land, continuing his defense of the innocent.

▲ Geist of Saint Traft ➤ Izzy

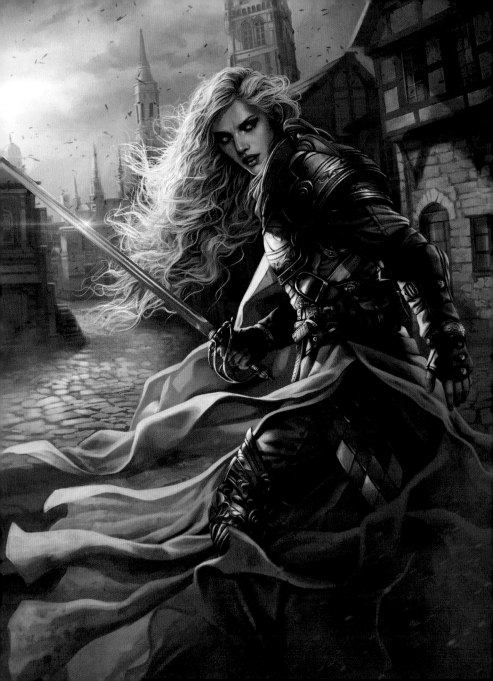

Thalia

The valiant young warrior priest Thalia is a master of martial combat, but her true strength lies in holding tightly to the embers of hope during the long nights. Hero to the plane of Innistrad twice over, she first thwarted a zombie invasion of the capital, where she burned the outer ring of the city to destroy the zombie horde invading her home.

Later, when the archangel Avacyn she had once so steadfastly believed in began to turn against humanity, Thalia followed her conscience. She refused to heed the increasingly cruel and paranoid church, striking out on her own to protect humanity. With benevolent geists aiding them, her forces were able to hold off the incursion of eldritch monstrosities that threatened to overrun their beloved home.

◄ **Thalia, Heretic Cathar** ✒ Magali Villeneuve

▲ **Thalia, Guardian of Thraben** ✒ Jana Schirmer & Johannes Voss

Hanweir

The people of Hanweir Township have always been close. The influence of the Eldrazi titan Emrakul drove the town to madness, and they declared themselves an independent province. As the Titan's influence grew on the town, so did the townspeople's bond with one another. And the town grew. And grew. Until the writhing mass that was once Hanweir Township began to move on its own. . . .

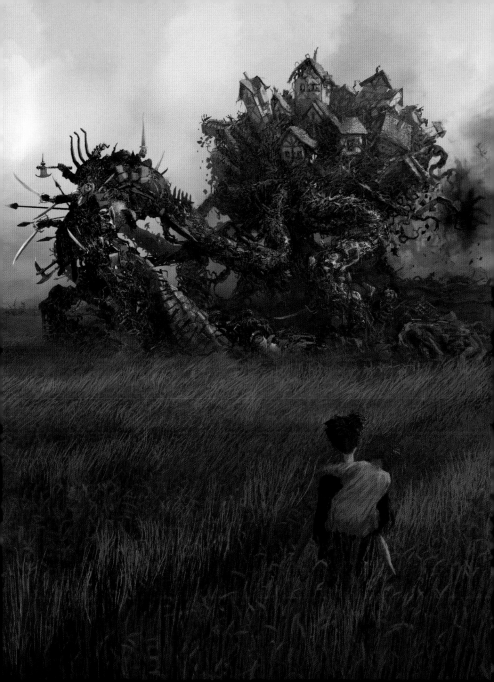

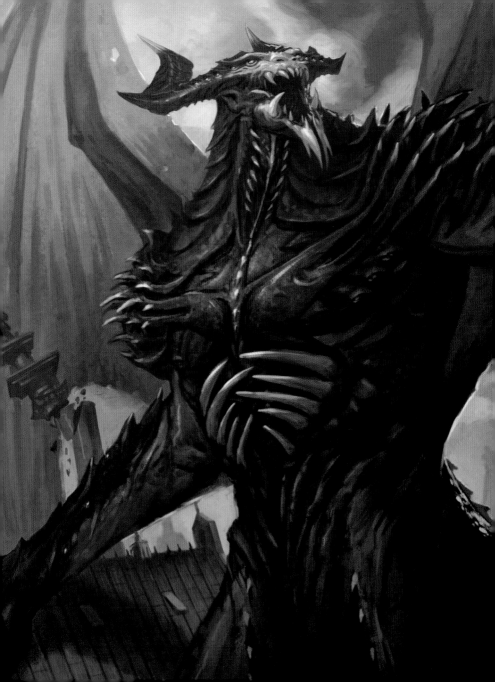

Withengar

Few creatures inspire the terror and dread of Demonlord Withengar. A massive demon of terrible power, Withengar was so mighty that even death could not stop him. To prevent the demon's reincarnation, a mystical blade called Elbrus was forged as his prison, and the demon was bound within. The cultist followers of Withengar tricked the warrior priest Saint Traft into slaying innocents, releasing the seal on Withengar's prison. The angels of Innistrad avenged Traft and slew the demon, but such dark power is never dormant for long.

◄ **Withengar Unbound** ✎ Eric Deschamps

▲ **Elbrus, the Binding Blade** ✎ Eric Deschamps

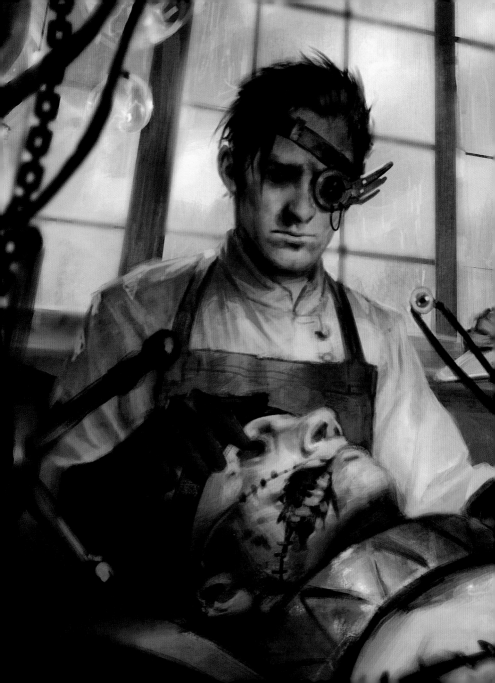

Geralf Cecani

The twins Gisa and Geralf were the spoiled scions of a noble lineage with a dark secret. Their constant squabbling as children evolved into a necromantic rivalry as adults. Geralf took after his mother and became a stitcher, a necromancer who uses alchemy to create zombie servants through the grafting of body parts rather than magical spells.

When he and his sister decided to pause their feud to destroy the capital, Geralf snuck inside the city and slew the pontiff who led humanity and the church. Devoid of its leader, the city was ripe for invasion, but the twins' plan was stymied by the city's desperate defenders. Now Geralf believes himself to be above the petty sibling rivalry that defined him. His work has earned him the notice of the greatest alchemist on Innistrad, and under his new mentor he works to perfect his craft.

◄ **Stitcher Geralf** ↜ Karla Ortiz

▲ **Prized Amalgam** ↜ Karl Kopinski

Gisa Cecani

Where her brother focused on necromancy through alchemy, Gisa learned the ancient magic of reanimation. Gisa cares little for her brother's obsessive attention to detail, focusing on quantity of zombies servants over quality. When the twins' combined assault on the capital failed, her brother escaped, while Gisa was captured.

Although her brother sent zombies to rescue her, Gisa was either too proud or too insane to recognize his aid. Not one to say thank you, Gisa instead focused on renewing their rivalry, but found her brother focused on other tasks. Although she'll never admit it, her brother's indifference frustrates the necromancer, motivating her to ever more twisted acts as a cry for attention.

▲ **Gisa's Bidding** ❧ Jason Felix
▸ **Ghoulcaller Gisa** ❧ Karla Ortiz

Ulrich

The curse of lycanthropy on Innistrad is rarely embraced by the were-wolves it creates—but come nightfall and moonrise, they join together to hunt in howlpacks anyway. Ulrich is not one of those who regrets his curse. Having long since shed his humanity, he leads his wolfpack on joyous hunts, slaughtering any human who gets in their way.

Ulrich does not return to civilization when he returns to human form, instead choosing to remain with his pack in the wild. While Ulrich himself embraces his feral identity, he does not care how his pack feels about being werewolves, only that they run with him in the night.

▲ **Ulrich of the Krallenhorde** 🐾 **Slawomir Maniak**

▸ **Ulrich, Uncontested Alpha** 🐾 **Slawomir Maniak**

THEROS

Myth and reality are intertwined more closely on Theros than anywhere else in the Multiverse. The gods themselves look down upon Theros from the starry realm of Nyx, appearing as constellations in the night sky to the mortals below. Nyx itself is connected to the collective unconscious of mortals, and their shared beliefs shape the gods.

Mighty heroes and champions of the gods, slay monsters, and foul beasts threaten the cities of Theros. Three mighty cities—the scholarly Meletis, the martial Akros, and the woodland Setessa—dominate human civilization. Leonin warriors live beyond the cities in nomadic encampments, while the Returned, undead escapees from the Underworld, linger in a half-life in long fallen cities.

The nature of the divine on Theros means the pantheon of the gods and their roles are ever-changing through the eons. The gods themselves were challenged by the planeswalker Xenagos, who was determined to prove them false by ascending into Nyx himself. He succeeded, disrupting the natural order of the pantheon until he was slain by the heroic planeswalker Elspeth Tirel. In a tragic turn, Elspeth's patron god, Heliod, turned on her in a jealous rage at her possessing power beyond his own.

Temple of Enlightenment ➤ Svetlin Velinov

Kynaios and Tiro

Legend tells the tale of an ancient mystical tyrant who once
ruled a mighty swath of Theros. The warriors Kynaios and Tiro,
spurred by their love for each other and for their people, led
an uprising against the tyrant. The legend says that a goddess
appeared to Kynaios and Tiro, drawn to their shared vision for
a beautiful city of freedom and enlightenment, and granted
them the power to overthrow the tyrant.

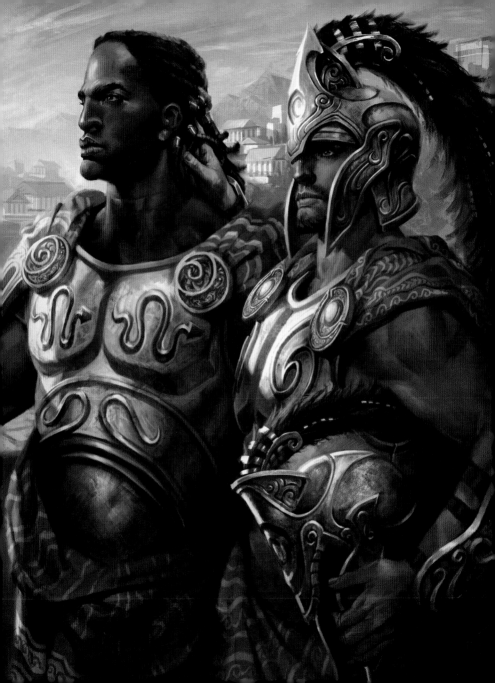

Daxos

An oracle of the god Heliod, Daxos was among the most powerful of his kind. He found a kindred spirit in the planeswalker Elspeth Tirel—a heroic soul unsure of her place in the world. Their fledgling love was not to be, as the cruel Xenagos cast a spell on Elspeth, making her believe she was lashing out at a Phyrexian monster, only to find she had slain Daxos. A grieving Elspeth made a pact with Erebos, god of the dead, to bring Daxos back. In a cruel twist, Daxos emerged from the Underworld as an undead Returned, devoid of identity. Heliod restored Daxos to life, imbuing him with some of the power of Nyx.

- ▲ **Daxos the Returned** ✒ Adam Paquette
- ▶ **Daxos, Blessed by the Sun** ✒ Lius Lasahido

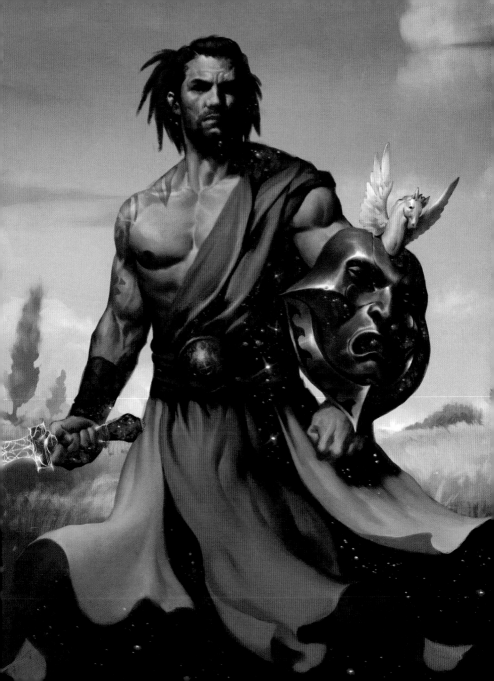

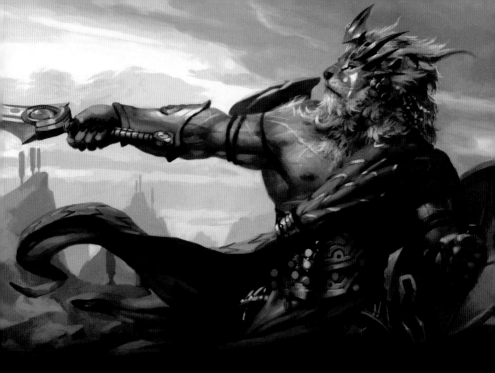

Brimaz

The catlike leonin of the plane of Theros remain aloof from humanity after being cast out ages before. Their kingdom lies far beyond the cities of humanity, beyond the mountains. Brimaz is their progressive king, who secretly wishes to begin mending the ties between leonin and human cultures. To that end, he has allowed a human chronicler to remain among his people and learn their ways. Brimaz hopes that his people will one day rejoin humanity on the leonin's ancestral lands.

▲ Brimaz, King of Oreskos ► Peter Mohrbacher

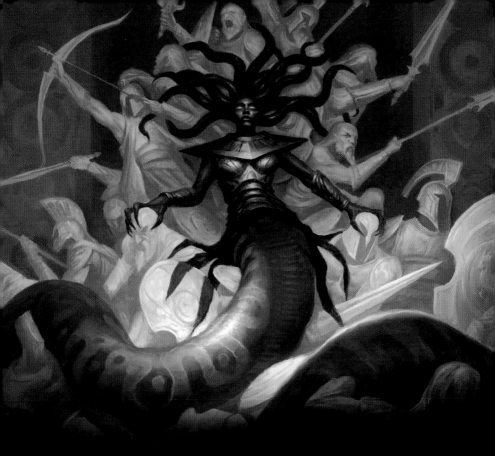

Hythonia

On a lonely isle in the sea, Hythonia reigns supreme as queen of her statuary. An immortal gorgon with a deep connection to a serpentine goddess, Hythonia enjoys tormenting those intrepid—or foolish—enough to intrude on her domain demanding her secrets. Few survive the experience, and fewer still make it back to the mainland with their prize.

▲ **Hythonia the Cruel** ☞ **Chris Rahn**

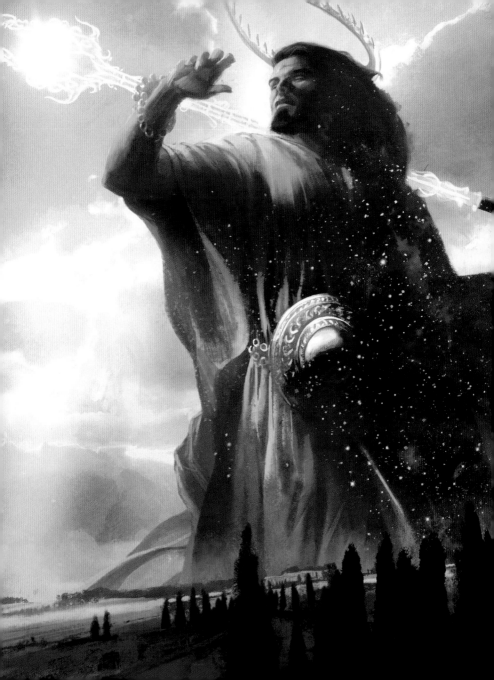

Heliod

Heliod, god of the sun, claims to be the head of the pantheon of Theros. This presumption enraged many of the other gods, most of all Purphoros, god of the forge. Purphoros forged Godsend, a divine blade with the power to cut the fabric of Nyx itself, thus killing a god. Purphoros attacked Heliod with Godsend, but Heliod disarmed Purphoros, and the blade fell from the heavens to Theros below.

When the weapon, once thought lost, reappeared in the hands of the mortal planeswalker Elspeth Tirel, Heliod tested her by sending her on an impossible task. Heliod was jealous of her power and knowledge of things beyond him, and he raged when she slew his oracle Daxos. When Elspeth struck a bargain with Erebos to return Daxos to life, Heliod was sick of the planeswalker's meddling. Upon her victory against the upstart godling Xenagos, Heliod took back Godsend and slew the planeswalker, sending her to the Underworld.

◄ Heliod, God of the Sun ✍ Jaime Jones

↑ Wrath of God ✍ Willian Murai

Erebos

Erebos, god of the dead, is said to have been created from the first shadow cast by the light of the sun on the god Heliod. When Heliod saw his shadow, he banished the darkness to the Underworld. There, Erebos embodied misfortune and the acceptance of one's destiny. Erebos has resigned himself to his fate and expects his subjects in the Underworld to do the same. While not explicitly cruel, Erebos has no patience for those who fight their fate. He will torment those who still struggle with hope until all trace of resistance is gone.

▲ **Erebos, God of the Dead** ✎ Peter Mohrbacher

▶ **Erebos, Bleak-Hearted** ✎ Chase Stone

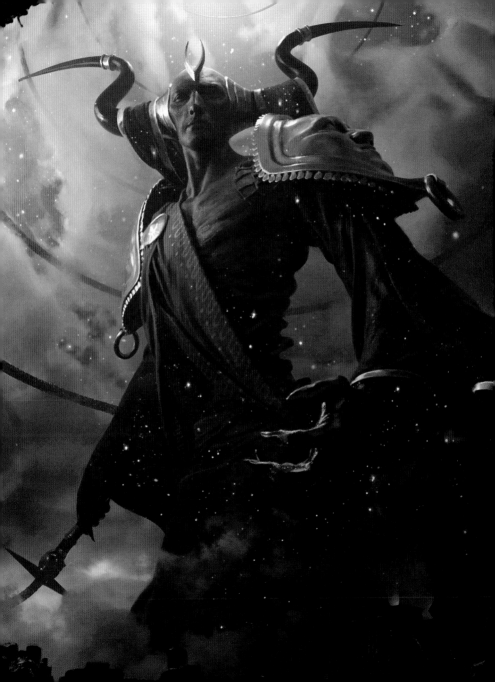

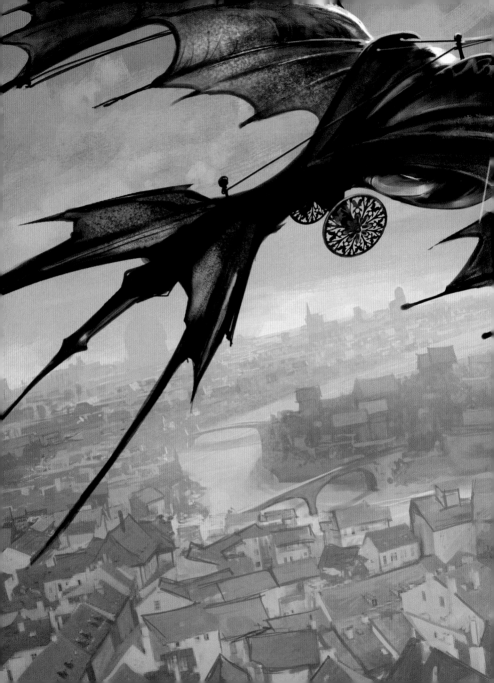

FIORA

The city of Paliano on Fiora is a bustling metropolis divided into the cloud-scraping High City and the lowlands below. There, the rich and powerful jockey for position, with complex conspiracies being hatched on a daily basis. The grand prize is nothing less than the throne itself.

Cogwork Spy ▸ Tomasz Jedruszek

King Brago

In life, King Brago was a sly politician and firebrand orator beloved by his people. Over the years, he built a strong coalition on reformation and eliminating corruption, until he was elevated to the position of king. After spending his life earning the crown, Brago decided that his reign would not be cut short by the tragedy of terminal illness and took steps to ensure his life beyond death.

Upon his death, the once fierce defender of liberty became an eternal tyrant. Brago's despotic turn left his opponents scrambling for solutions, until one day Kaya, a ghost-assassin planeswalker, appeared in the throne room, slaying the so-called Eternal King.

◄ **Brago, King Eternal** ◈ Karla Ortiz

▲ **Regicide** ◈ Chris Rallis

Queen Marchesa

Marchesa d'Amati, known as the Black Rose, learned from an early age that if she wanted power she would have to seize it for herself. Striking out on her own, her legitimate businesses provided cover as she gained connections through the criminal underworld. But Marchesa's ambitions didn't end at being queen of just a criminal empire.

Finding someone who could assassinate the ghost King Brago wasn't easy, but Marchesa's contacts put her in touch with the elusive ghost-assassin, Kaya. The king's reign was ended, allowing Marchesa to step in and "inherit" the throne through a succession decree of dubious origin.

▲ **Marchesa the Black Rose** ✎ Matt Stewart

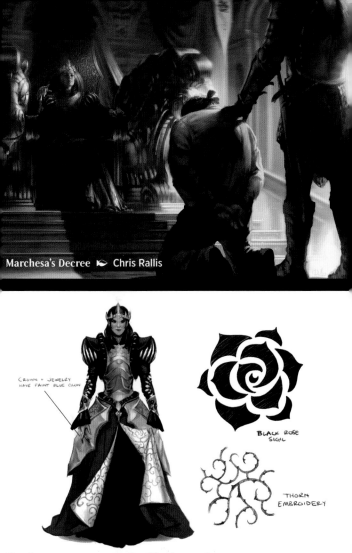

Marchesa's Decree ▶ Chris Rallis

CROWN + JEWELRY
HAVE FAINT BLUE GLOW

BLACK ROSE
SIGIL

THORN
EMBROIDERY

Marchesa concept art ▶ Cynthia Sheppard

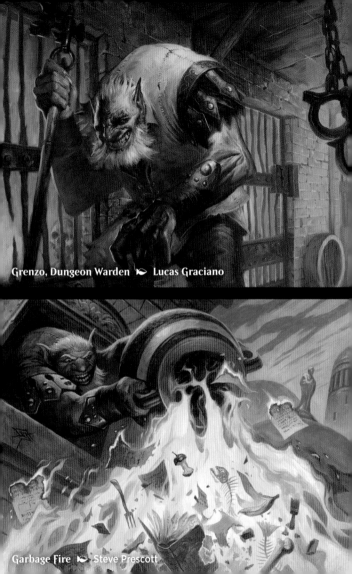

Grenzo, Dungeon Warden ❧ Lucas Graciano

Garbage Fire ❧ Steve Prescott

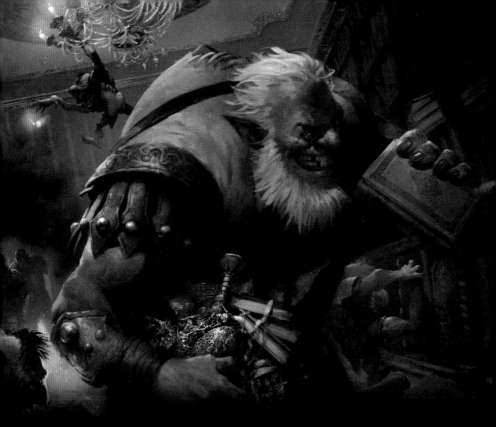

Grenzo

Where the other schemers of Fiora lay careful plans, Grenzo kicks over the table to see what happens and takes advantage of the ensuing chaos. The volatile dungeon keeper has never been respected by the humans of his home plane. He likes it that way. The highborn of Paliano would readily assume that a prisoner going missing was incompetence, not a seed sown to destabilize Grenzo's rivals. For the wily goblin, the enemy of his enemy is clearly a useful ally, and with a nudge in the right direction he'll let others do the work of taking down his foes.

▲ Grenzo, Havoc Raiser ▷ Svetlin Velinov

TARKIR

The course of Tarkir's history begins on Dominaria with the elder dragon twins Ugin and Nicol Bolas. Planeswalkers both, Nicol Bolas slew his brother in a rage. Ugin was reborn and restored as the spirit dragon and found a home on the plane of Tarkir, far away from his evil brother. On Tarkir, Ugin's presence sparked elemental storms, spawning new dragons from dragon tempests. To bring balance, Ugin gifted the five human clans magical powers to equal the marauding dragons.

Nicol Bolas discovered his brother was still alive and plotting against him, so he appeared on Tarkir to kill his brother once more. Upon Ugin's death, the dragon tempests ceased, and the five clans were able to slaughter the remaining dragons. More than a thousand years later, dragons were nothing but a memory and the clan leaders, known as khans, reigned supreme. The extinct dragons sparked an obsession in the planeswalker Sarkhan Vol, who returned to Tarkir with a fragment of the Eye of Ugin, the magical nexus of the Eldrazi prison on Zendikar. Approaching Ugin's bones, Sarkhan was transported in time to mere hours before Ugin's death.

This time when Ugin fell, Sarkhan was there. Ugin's body was encased in massive hedrons to recover. When Sarkhan returned to the future, he found that the dragon tempests had spawned out of control during Ugin's recovery, and the plane was dominated by five dragonlords in place of the khans. None but Sarkhan knew that history had been changed.

Stomping Ground ✒ Daarken

Alesha

In the ancient past of Tarkir, Alesha was a warrior of uncompromising skill. Upon earning her war name, Alesha claimed her identity as a woman and led her clan, the Mardu, with such ferocity that she was named khan. Alesha knew that true strength came from knowing oneself. Under her leadership, the Mardu faced the overwhelming might of dragons. Alesha discovered that the elder dragon ravaging their lands had no interest in ruling the Mardu, but instead invited the clans to keep up with her blazing speed.

▲ **Alesha, Who Smiles at Death** ✍ **Anastasia Ovchinnikova**

Zurgo

When the khans reigned supreme on Tarkir, Zurgo ruled the Mardu clan with cruelty and brutality. A mighty orc towering over his compatriots, Zurgo inspired fear rather than loyalty. He pursued the traitor Sarkhan Vol, a Mardu warrior who had disappeared years before, to the final resting place of Ugin the spirit dragon, but Sarkhan vanished before his eyes.

Suddenly, the world was changed. Instead of a brutal warchief, Zurgo was a humble servant of a mighty elder dragon. Now Zurgo Bellstriker, he is a mere messenger, signaling the tribe to the movement of dragons as they are led by the mighty Kolaghan.

▲ **Mardu concept art** ☙ **Daarken**

Silumgar

The elder dragon Silumgar's flight is winged death upon the night, his acid breath corroding flesh and stone wall alike. When Ugin's convalescence caused his brood to spawn from the dragon tempest like an overwhelming tide, Silumgar took advantage of his newfound numbers. He broke the clans that once dominated the plane and rivaled the dragonbroods, and he assumed the role of dragonlord, ruler of both dragons and the lesser species. His subjugation of the former Sultai clan lands has resulted in a complete power shift. The living and the dead serve the dragon's whims, and all exist for Silumgar's personal enrichment.

◄ **Silumgar, the Drifting Death** ▻ Steven Belledin

▲ **Dragonlord Silumgar** ▻ Steven Belledin

Sidisi

The ruthless Sidisi slithers and schemes for power at the expense of all others. For over a millennium, the snakelike naga had ruled the decadent Sultai clan with scaled fists. Backed by fickle demonic masters, the naga had overthrown the humans of the clan. That version of events was unwritten by the time-traveling Sarkhan Vol.

In a world where the dragonlords usurped the khans, Sidisi was instead vizier to the opulent dragon Silumgar. Sidisi was caught plotting against her master and executed, only to be reanimated as a zombie to continue her duties. The now-undead Sidisi continues to scheme against her master, but this time much more carefully.

▲ **Sidisi, Undead Vizier** ⬿ Min Yum
▸ **Sultai Ascendancy** ⬿ Karl Kopinski

Taigam

The warrior monks of the Jeskai clan were courageous and brave, none more so than the legendary Taigam. When Taigam was passed over for leadership of the clan, the rapacious warrior dishonored himself by defecting to the Sultai. Disappointed at his wasted potential, many wondered what would have happened if things had been different.

Then Sarkhan Vol changed the timeline, creating a world dominated by dragonlords instead of khans. In this version of events, Taigam retained his honor and integrity. Although he still strived for power, he become the loyal retainer of the elder dragon Ojutai. Taigam's scheming served to elevate him to the upper echelons of the Ojutai clan, among the highest ranks to which a human can aspire.

▲ **Taigam's Scheming** ▻ Svetlin Velinov

▸ **Taigam, Ojutai Master** ▻ Simon Dominic

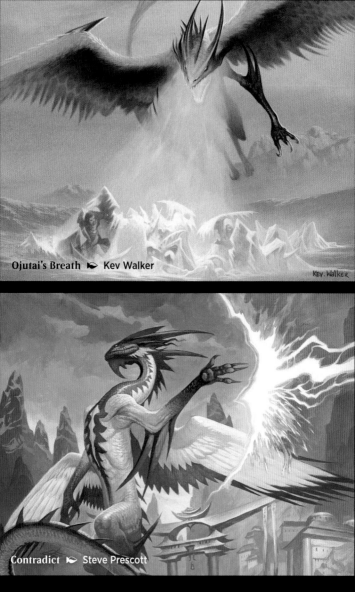

Ojutai's Breath ▸ Kev Walker

Kev.Walker

Contradict ▸ Steve Prescott

Ojutai

Dragonlord Ojutai is the most cunning and wise of the elder dragons of Tarkir. His wisdom is matched only by his martial prowess and piercing, polar breath. When the dragon tempests spawned dragons in excessive numbers, Ojutai seized the opportunity. He crushed the dragon-killing monks of the Jeskai clan.

With the dragon-slayers gone, Ojutai reshaped the clan in his image, scouring any Jeskai tradition that did not align with his own philosophy. Ojutai led the clan in a similar manner as they had existed before but with dragons at the top, where they belonged. Ojutai rules his clan as its unquestioned master, and his clan reveres him as the Great Teacher.

▲ **Dragonlord Ojutai** ◈ **Chase Stone**

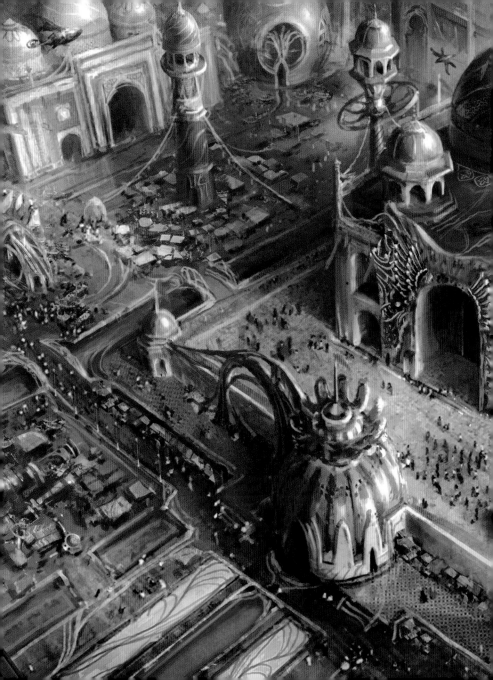

KALADESH

Exquisitely crafted inventions abound on Kaladesh, a plane of mechanical marvels. Everything on Kaladesh is a work of art, from the tallest building to the smallest trinket. The artistry of Kaladesh's inventors has resulted in a plane of bright colors and gorgeous filigree devices. The plane's prosperity is due in large part to its abundance of aether, a powerful magical resource that is ordinarily quite rare on the planes of the Multiverse.

The people of Kaladesh have learned to harvest and refine their plane's bountiful aether, fueling an industrial boom. The Consulate, a bureaucratic governing body, stepped in to regulate this explosion in industry. While aether may be a nearly unlimited resource, the amount that can be harvested and refined for safe use is limited. The restrictions of the Consulate have caused many inventors to chafe under the increasingly authoritarian regime. These malcontents are collectively designated as "renegades" and branded as dangerous criminals by the Consulate.

The Consulate and the loosely affiliated renegades coexisted peacefully for a long time. Many in the Consulate were willing to overlook the renegades' mostly harmless defiance. As the Consulate regime skewed more and more authoritarian, the renegade network coalesced into a true rebellion. After ousting the authoritarian regime, peace has once more come to Kaladesh as the Consulate implements sweeping reforms.

Torch of Defiance Story Art ❧ Jonas De Ro

Pia Nalaar

The desire for invention burns brightly in Pia Nalaar, a master artificer of the plane of Kaladesh. Pia Nalaar is a renegade, a malcontent against the authoritarian Consulate regime. Together with her husband, Kiran, they built their inventions in secret, outside of the Consulate's eye. They supplemented their activities with illicit trade in the tightly regulated power source, aether.

When their daughter was caught with rare, outlawed magical abilities, a tragic sequence of events led to Kiran's death and their daughter's disappearance. Pia spent years locked away in a secret Consulate prison, and upon her release she united the loose renegade networks into a true rebellion. Her daughter, revealed to be the planeswalker Chandra Nalaar, returned and gave the rebellion the final spark it needed. They overthrew the Consulate and rebuilt it with Pia herself as a new consul, guiding a more just system.

- ▲ **Welding Sparks** ⟿ Raymond Swanland
- ▸ **Pia and Kiran Nalaar** ⟿ Tyler Jacobson

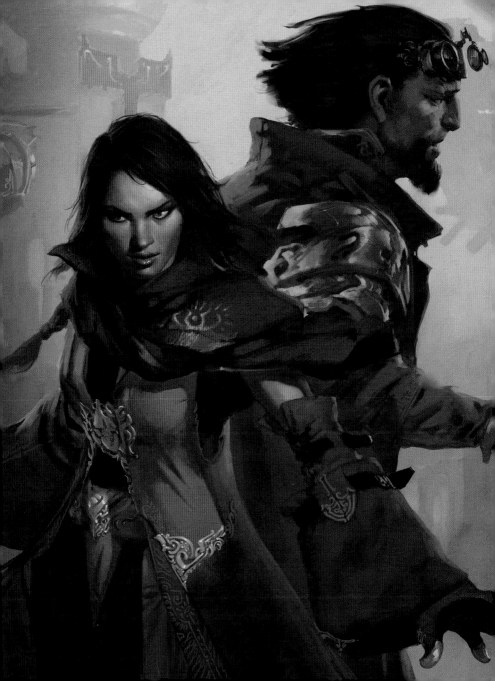

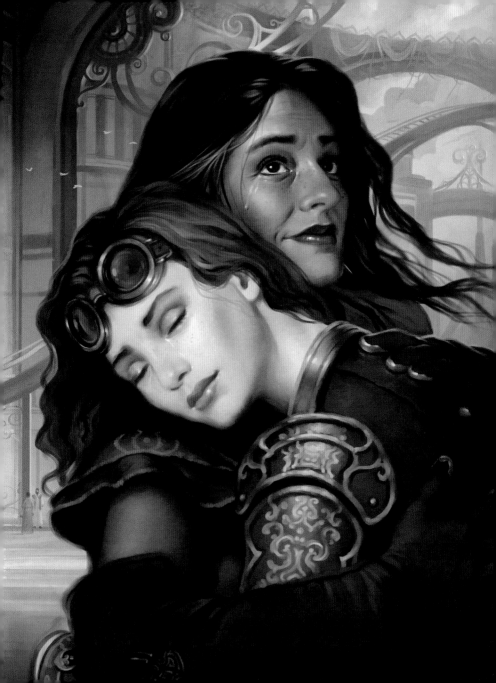

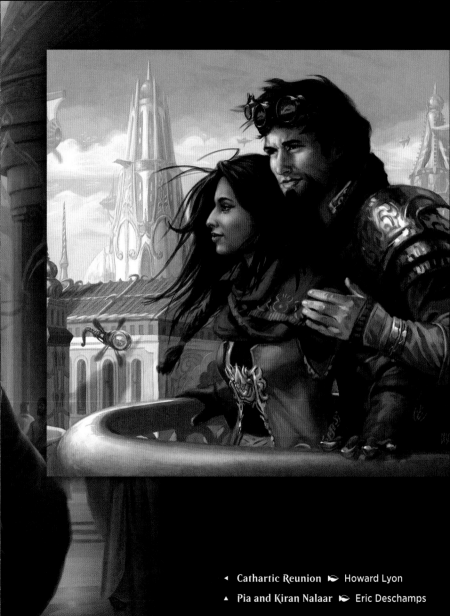

◄ Cathartic Reunion ✎ Howard Lyon

▲ Pia and Kiran Nalaar ✎ Eric Deschamps

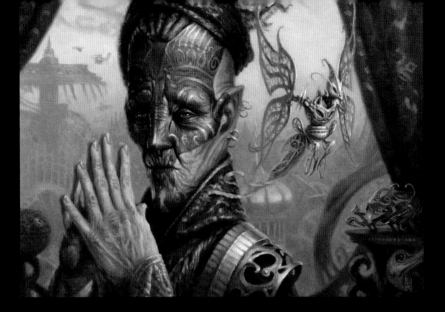

Padeem

The blue-skinned vedalken of Kaladesh were uniquely suited to the order and structure of the Consulate. Making a name for herself as a young woman with self-repairing armor, Padeem was elected to the position of Consul of Innovation. Padeem has served with distinction, promoting growth and creativity among the sometimes wild inventors of Kaladesh.

Of all the consuls, Padeem is known for her fair appraisal, guiding nascent projects to fruition with her keen eye. She demands much, but despite her high expectations and direct criticism, inventors who come before her leave encouraged even in failure.

◄ **Padeem concept art** ➤ Tyler Jacobson

▶ **Padeem, Consul of Innovation** ➤ Matt Stewart

Sram

The dwarf Sram is a no-nonsense master engineer. As Senior Edificer, he is responsible for the complex infrastructure that supports Kaladesh's population. His greatest achievement is the Aether Hub, a complex structure that feeds the magical power source across his great city.

Sram cares for his people more than politics, and when the Aether Hub was threatened by renegades, he prioritized people over property. He and his team work tirelessly to repair the damage done by the recent revolution.

▲ **Sram concept art** ✒ **Tyler Jacobson**

▶ **Sram, Senior Edificer** ✒ **Chris Rahn**

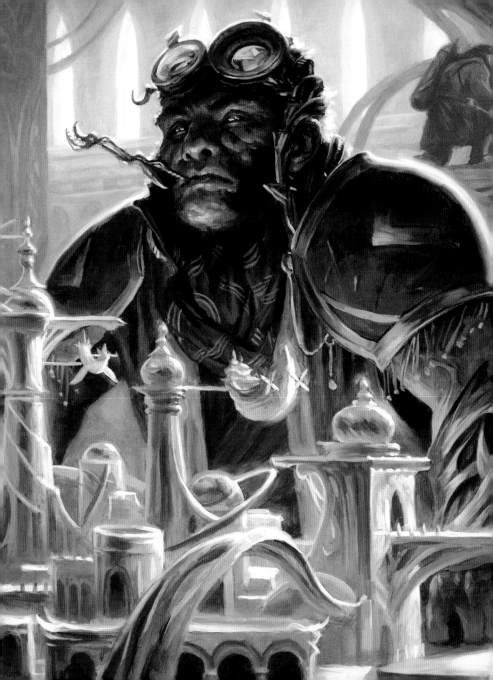

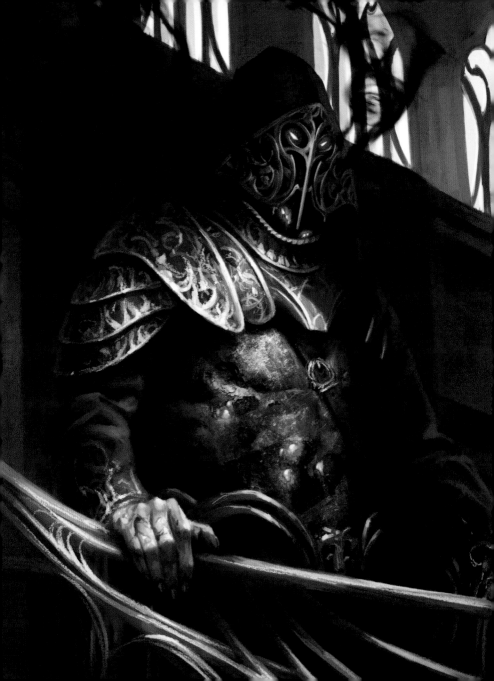

Gonti

The criminal kingpin Gonti is an aetherborn of boundless appetites and greed, but there is one thing Gonti desires beyond all else: more time. On the plane of Kaladesh, the aetherborn manifest fully formed from the aether refineries as genderless beings who are born knowing exactly how long they have left to live. The aetherborn never waste a moment of their lives that could be filled with a great experience.

Unhappy with their short life span, Gonti has spent a career implementing methods by which to extend their own life. Gonti traffics in smuggled aether and has thrown their weight and criminal empire behind the burgeoning rebellion on Kaladesh—for a price, of course—taking advantage of the chaos for their own nefarious ends.

◄ **Gonti, Lord of Luxury** ► Daarken
▲ **Gonti concept art** ► Kieran Yanner

AMONKHET

The people of Amonkhet have always persevered against their harsh desert home, where horrors lurk just outside of their grand city of Naktamun. The gods strived to keep their people safe, erecting a magical barrier called the Hekma to protect their oasis of civilization. Then came the evil elder dragon Nicol Bolas.

Nicol Bolas had grand designs for Amonkhet, plans that required the subservience of its pantheon of gods. The elder dragon twisted the gods' minds, making them believe that Bolas was the God-Pharaoh, lord of the pantheon. As God-Pharaoh, he gave the gods and mortals of Amonkhet a new, unholy task. The people of Amonkhet were to compete in five deadly trials, the goal of which was to prove themselves worthy of an honored place in the God-Pharaoh's afterlife. Those who proved worthy were slain, their bodies whisked away to the Great Necropolis.

When Nicol Bolas returned, the people and gods were horrified to learn that everything they believed in was a lie. Nicol Bolas unleashed the truth upon them. From the Great Necropolis, an army of undead Eternal warriors called the Dreadhorde emerged—the so-called worthy. The gods realized too late that they had been deceived, their pure purpose twisted to evil. Their purpose finished, they fell one by one before Bolas, until only one was left to lead her people to safety.

Amonkhet ⮞ Titus Lunter

Hazoret

The worshippers of Hazoret, the goddess of zeal, fight for her with unmatched fervor. Hazoret, wielding her deadly twin-pointed spear, fights for them with no less ardor. The last benevolent god of Amonkhet, she and her siblings were once twisted by an evil force from beyond their plane, forced to carry out ritual trials that belied the true slaughter in a divine pantomime. Hazoret herself delivered the killing blow to the victors, promising them an honored place in the afterlife.

Instead, what awaited them was servitude in undeath as Eternal warriors. When the horrors of this cruel plot were revealed, Hazoret's mind was cleared. The goddess of zeal cut a swath through the Eternals to guide her people to safety.

◄ **Hazoret the Fervent** ▻ Joseph Meehan

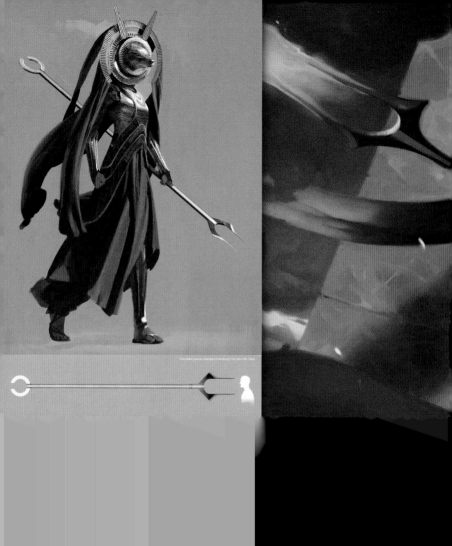

One point a person champion's firstmost, the other his chest.

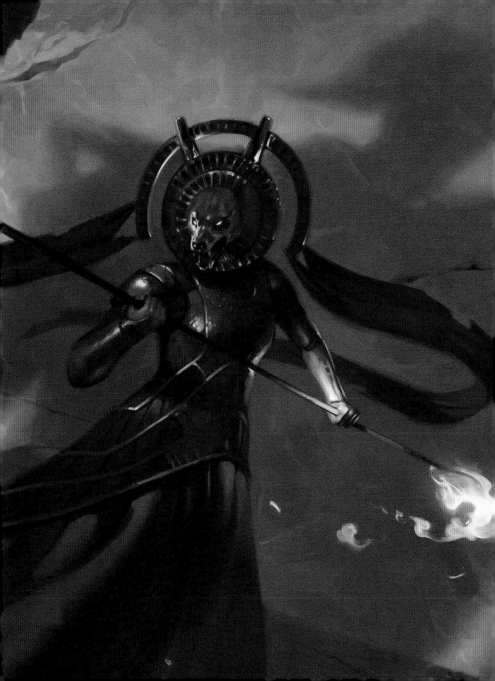

Bontu

The god of ambition, Bontu, valued nothing more than the struggle for greater power in her adherents. When the other gods were twisted into fulfilling the supposed God-Pharaoh Nicol Bolas's greater purpose, Bontu served willingly. Bontu maintained the facade of the ritualistic slaughter called the trials until the return of the God-Pharaoh . . . and was rewarded for her service with death.

Like the people she led to their deaths, it was not the end for Bontu. Mummified and coated in the magical blue stone, lazotep, Bontu was reborn as part of the army of Eternal warriors under the God-Pharaoh's command.

◀ **Bontu's Last Reckoning** ⤳ Victor Adame Minguez

▲ **God-Eternal Bontu** ⤳ Lius Lasahido

Djeru

Swift and bold, brave and true, Djeru exemplified the divine virtues of the gods of Amonkhet. As one of the finest warriors Amonkhet had ever produced, Djeru excelled at the five trials presented to him as his path to the glorious afterlife. He had fought alongside and then slain his childhood friends to honor the gods. All so that he could be proven worthy. Djeru kneeled before the god Hazoret after succeeding in the final trial. It was all a lie, a cruel farce by his beloved God-Pharaoh to build an army of undead warriors.

Djeru's anointing was prevented by the arrival of the God-Pharaoh Nicol Bolas himself, come to reap what he had set into motion decades before. With the stark truth laid bare, Djeru devoted himself to leading his people to safety alongside Hazoret. His faith unwavering in his heart, he slew a god twisted by evil to save the last true god and lead his people to salvation.

▲ Djeru, With Eyes Open ◆ Kieran Yanner

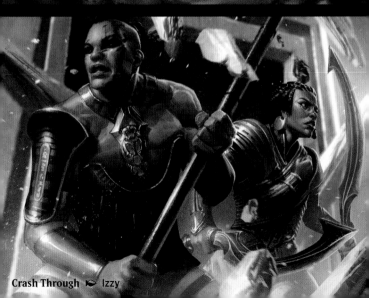

Djeru's Renunciation 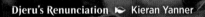 Kieran Yanner

Crash Through ☙ Izzy

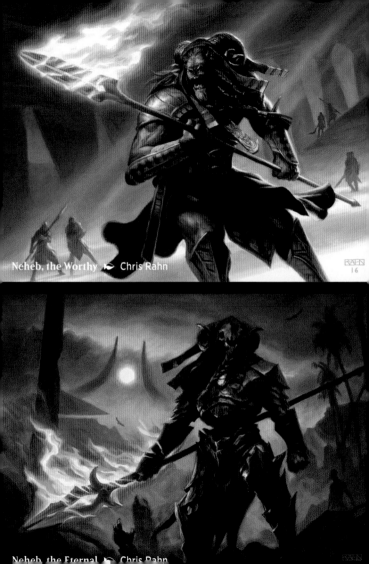

Neheb, the Worthy Chris Rahn

16

Neheb, the Eternal Chris Rahn

Neheb

Neheb, the mighty minotaur warrior, believed fervently that completion of the sacred trials of Amonkhet would result in him taking his rightful place in the afterlife. Unfortunately, upon emerging victorious from his trials and being found worthy, what he found wasn't a hallowed place in the afterlife. Instead, he was given undeath as part of the God-Pharaoh's Eternal army. As a nightmarish Eternal, Neheb and his fellow Eternals in the Dreadhorde took to the streets, slaying anything that still lived to grow their undead ranks and serve the God-Pharaoh's will.

Neheb, Dreadhorde Champion · Igor Kieryluk

IXALAN

Ixalan is a plane upended by the machinations of planeswalkers. Over a millennium ago, planeswalkers brought to Ixalan an artifact of unimaginable power: the Immortal Sun. Those who controlled the Immortal Sun would have access to godlike abilities, but none were worthy of its power. Hidden away centuries ago to keep it out of mortal hands, the Immortal Sun had faded into myth.

The Legion of Dusk believed the Immortal Sun to be their birthright; the vampire aristocracy wanted to lay claim to it to undo their curse of undeath. They came from across the sea to the continent of Ixalan to claim it. The Sun Empire that rules Ixalan commanded the fearsome dinosaurs of the continent against the Dusk Legion's invasion. Caught in the middle were the Brazen Coalition, a band of refugees displaced by the Dusk Legion, who turned to piracy when the Sun Empire denied them succor, and the enigmatic River Heralds, tribes of merfolk who knew the secret location of the Immortal Sun.

War broke out on Ixalan over the Immortal Sun. Its ancient hiding spot was revealed, but the Immortal Sun was snatched away by interloping planeswalkers. The Sun Empire has repelled the Dusk Legion invaders and prepared a force of their own to take the war back to the Legion's home.

Ixalan ☙ Tyler Jacobson

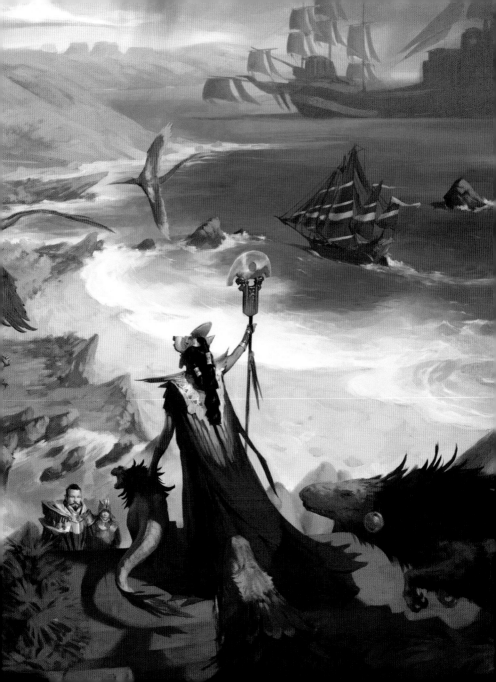

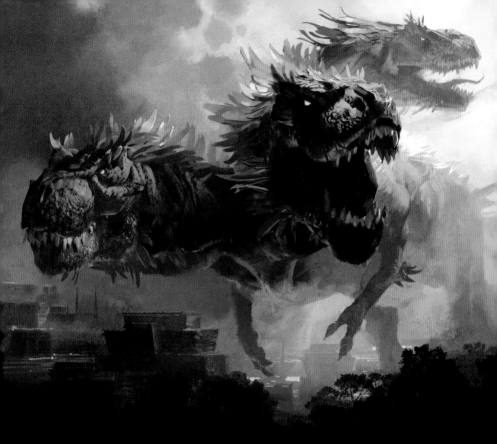

Zacama

Towering over the mightiest kapok tree, its radiance blazing like the sun, the elder dinosaur Zacama is ruler of all it surveys. Zacama embodies the Threefold Sun, the divinity of the dinosaur-worshipping Sun Empire. Whether Zacama inspired the beliefs of the Sun Empire or is merely their truest embodiment is irrelevant. The saurian behemoth represents a source of great strength and terrible calamity, capable of crushing enemies beneath its might.

▲ Zacama, Primal Calamity ◆ Jaime Jones

Elenda

Elenda began life as a monastic warrior charged with the protection of her realm's greatest treasure: the Immortal Sun. When an ancient creature from across the sea stole her charge, she would let nothing, not even death, stop her from returning it. Her quest led her to humble herself before dark powers, sacrificing her life to extend her quest in undeath as a vampire. Elenda spread her gift to her homeland, forming the Legion of Dusk, before returning to her journey.

The Legion grew corrupt during Elenda's long absence, and her gift—meant to inspire humility—has been abused by the decadent and corrupt. Now Elenda returns to either set them on the path of righteousness or destroy what she has wrought.

▲ **Elenda, the Dusk Rose** ✒ Chris Rahn

Kumena

The merfolk Kumena commands the waters and plants of Ixalan, bending them to his will, and then restoring them once finished. As a Shaper, a master of nature magic, he is the leader of his merfolk tribe, but he pursues his own self-interest. Having lived in peace with the neighboring humans for centuries, the encroachment of foreign powers has driven Kumena to acquire what his people have been charged with safeguarding: the Immortal Sun.

Entrusted to Kumena's people long ago and hidden away lest they be tempted to use it, the Immortal Sun might be the best hope of Ixalan's merfolk to defend against the invaders. But Kumena's reach exceeded his grasp, and the Immortal Sun was taken from him in the desperate race to claim it.

- ▲ **Kumena's Awakening** ↣ Zack Stella
- ▸ **Kumena, Tyrant of Orazca** ↣ Tyler Jacobson

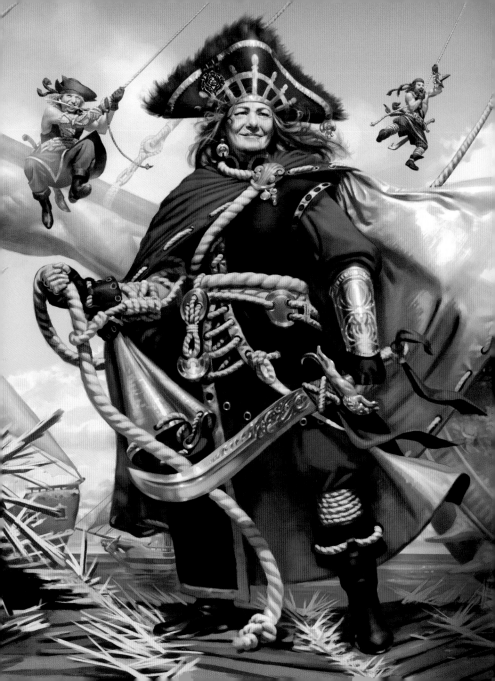

Beckett Brass

Among the pirate bands of Ixalan, no name commands more respect than that of Admiral Beckett Brass. Brass grew her command from a single ship, the *Scourge*, into the massive Fathom Fleet by outfighting or out-smarting her rivals. She commands fierce loyalty from her crew and admiration from her rivals.

◄ **Admiral Beckett Brass** ✒ Jason Rainville

▲ **Admiral's Order** ✒ Slawomir Maniak

ELDRAINE

Long ago, Eldraine was split between the Realm of humanity and the Wilds. The Realm became a place of order and the knightly virtues: loyalty, knowledge, persistence, courage, and strength. Aspiring knights venture to the five courts of the Realm, each of which embodies one of these virtues. If the aspiring knight can prove themselves, they're welcomed into the court as a knight. Knights who display more than one virtue may even become members of more than one court, supposing they can continue to prove themselves.

The creatures, faeries, and other folk of the Wilds disdain the humans' orderly society. By contrast, the Wilds are a tumultuous place. The diverse inhabitants, collectively known as the fae, match their untamed environment. There, magic is unpredictable and mysterious. Paths through the Wilds aren't logical, and humans are easily turned around, many lost forever. Likewise, the fae are mercurial creatures, as likely to aid humans for their own inscrutable purposes as they are to harm them for any perceived slight.

As magical creatures from ferocious dragons to faerie pranksters venture out of the forest, the Knights of the Realm maintain balance, keeping humanity safe from the chaos of the Wilds.

Castle Vantress ✒ John Avon

King Algenus Kenrith

The High King of Eldraine, Algenus Kenrith earned the title through his dedication to the five knightly virtues of loyalty, knowledge, persistence, courage, and strength. As a youth, Algenus was chosen to undergo the High Quest and become a knight of all five courts of the Realm. Only by embodying all the virtues of the Realm could a champion ascend to the throne.

Together, Algenus and his queen rule a prosperous Eldraine. Algenus is beloved by his people, his natural charisma and empathetic nature making him a massively popular figure. The key to his reign, however, is the quiet wisdom of Queen Linden. Together they're a force to be reckoned with and the greatest rulers Eldraine has had in generations.

▲ **Kenrith, the Returned King** ↤ **Kieran Yanner**

Kenrith Family Portrait ⊱ Ryan Pancoast

Happily Ever After ⊱ Matt Stewart

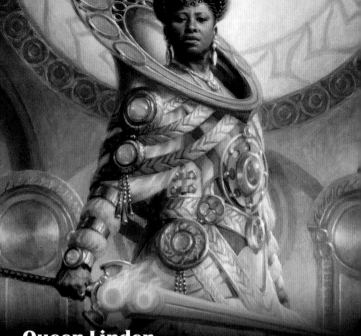

Queen Linden

Linden earned her third knighthood by the time she was twenty-five and was given the right to attempt the High Quest and become ruler of the Realm at same time as the young Algenus Kenrith. These two rivals found on their trav a camaraderie that blossomed into something more. After his ascension to th throne, they married and have raised four children together.

When the High King went missing, Linden stepped in as queen to keep th five kingdoms together. Not having completed the High Quest herself, the ot kingdoms see this as Linden overstepping her bounds. But Linden has alway been her husband's closest advisor and wants to keep the kingdoms togethe his absence.

Linden, the Steadfast Queen ▷ Ryan Pancoast

Rankle

Rankle, a mercurial fae of the Wilds, delights in tormenting the stupid knights of
the Realm and their idiotic virtues. To an outsider, Rankle's antics seem point-
less, and they frequently are, but while most faeries of his kind are annoyances,
Rankle's pranks are downright cruel. Rankle shows an occasional glimmer of
low cunning, concocting elaborate plots to create a desired outcome. The price
to win an audience with Rankle can range from compromising one's virtues to
plucking out an eye, depending on his mood and sense of humor that day.

▲ **Rankle, Master of Pranks** ↣ Dmitry Burmak

King Yorvo

King Yorvo is a colossal giant, standing head and shoulders above even the mightiest of his kind. Long ago, Yorvo's father deposed a corrupt human king of the plane Eldraine and became a ruler himself, demonstrating the proper virtues of strength to humanity. Yorvo took over his father's crown many human generations ago, and there isn't a human alive who remembers a time when he wasn't king. Yorvo stands between the human Realm and the Wilds, guarding a gateway deep into the fae lands.

▲ **Yorvo, Lord of Garenbrig** ▶ Zack Stella

IKORIA

Mysterious crystals dot the landscape of Ikoria, fueling the growth, evolution, and power of the plane's dominant monsters. Here, humanity is largely contained to rare sanctuaries, protected cities where civilization can flourish as long as they can fend off monster attacks. Few people are strong or brave enough to venture into the wild, but those who do are among the strongest and bravest humanity has to offer. Ostracized from the rest of humanity are the bonders, humans with the ability to connect with the plane's monsters. A bonder and monster together are a force to be reckoned with in the rugged wilderness of Ikoria.

Zagoth Triome ☙ **Eytan Zana**

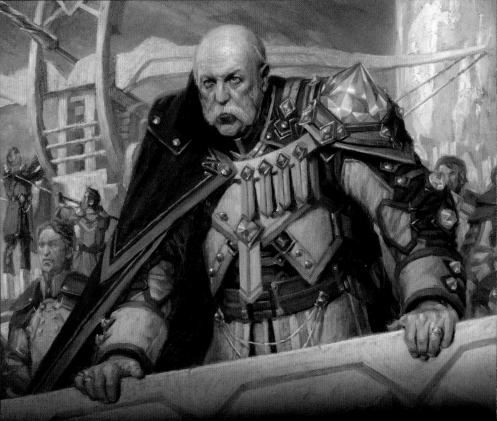

General Kudro

Responsible for protecting the largest bastion of human civilization on the plane, General Kudro leads the Drannith defense force known as the Coppercoats. Kudro's responsibility to the tens of thousands of lives behind the city walls weighs on him heavily, and the emergence of bonders has pushed him to extremes. Unwilling to accept that bonders are anything other than dangerous abominations, Kudro is set on rooting them out. To Kudro, a bonder is little better than a monster, and he believes the only good monster is a dead monster.

▲ **General Kudro of Drannith** ↣ **Ryan Pancoast**

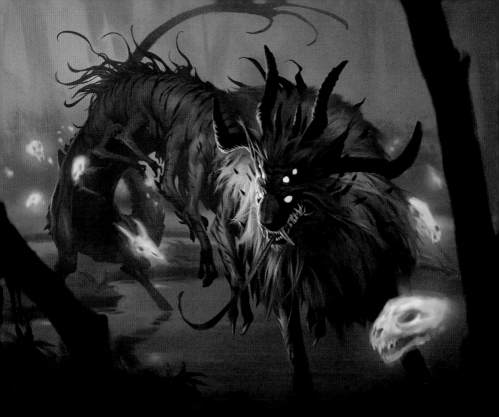

Nethroi

The horrific apex monster Nethroi lurks in the chilly environs of its lowland home. Creeping through the twisted helica trees, Nethroi hunts its prey with shadowy grace. Changed by the magical crystals of its home, Nethroi is an amalgam of the plane's most fearsome predators. It is said that Nethroi's breath can reanimate the leftover carcasses ubiquitous to the lowlands. And by restoring the rotting remains to shambling unlife, Nethroi has a veritable army to use against human and monster alike.

▲ **Nethroi, Apex of Death** ▸ **Slawomir Maniak**

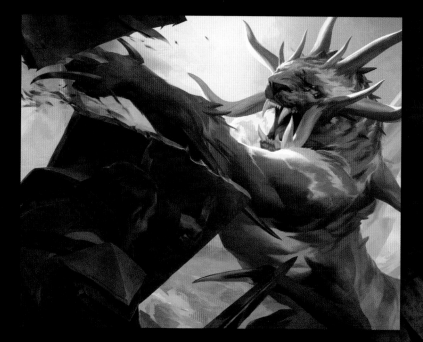

Snapdax

Prowling the arid steppes of its territory in search of
prey, the ferocious Snapdax strikes without warning.
Those unlucky or unwitting enough to find themselves
Snapdax's next meal are torn asunder by the apex pred-
ator's razor claws. Even the finest shield offers sparse
protection against Snapdax's might. Its victims are
dragged back its lair, a massive cavern full of the vicious
creature's trophy kills.

▲ **Will of the All-Hunter** ↪ Viktor Titov

▸ **Snapdax, Apex of the Hunt** ↪ Viktor Titov

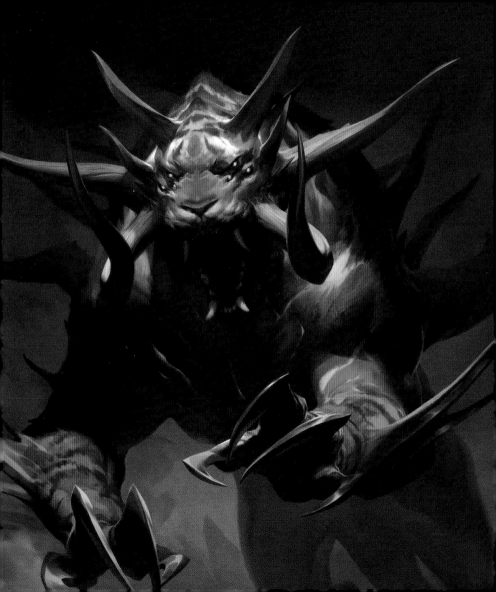

Brokkos

Legends tell of the colossal Brokkos roaming its wetland home at the dawn of the world, when the tremendous mangroves were mere saplings. The inspiration from such stories comes from the monster's intrinsic connection to the world. Seemingly a natural part of the wetlands, Brokkos blends into its environs to hibernate as the seasons change, only to emerge again from its slumber days or weeks later. When awoken, the implacable Brokkos meets challengers with a thunderous charge, and any creature foolish enough to stand against it is quickly trampled.

Brokkos, Apex of Forever ▷ Daniel Warren Johnson

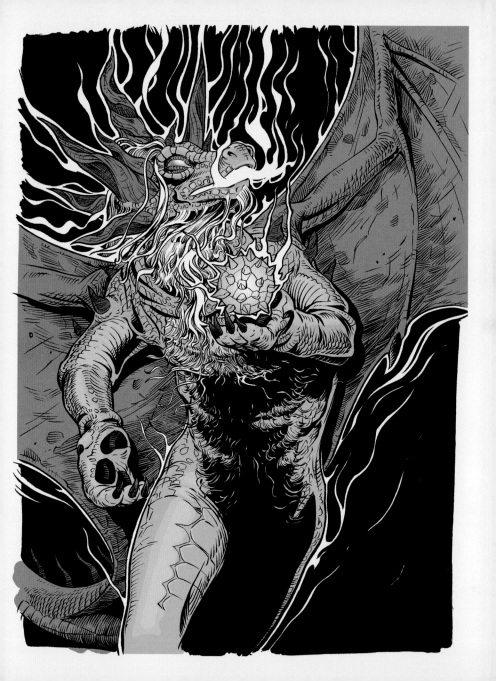

Illuna

The mysterious crystals of Ikoria flourish in the wilderness of Illuna's territory. An awe-inspiring ethereal being, Illuna can be found drifting between crystal formations working elemental power to some ineffable purpose. When Illuna deigns to speak aloud, those who have heard its voice are enraptured by its uplifting, otherworldly resonance.

◄ **Illuna, Apex of Wishes** ▻ Justine Mara Andersen
▲ **Illuna, Apex of Wishes** ▻ Chris Rahn

ACKNOWLEDGMENTS

First and foremost, I'd like to acknowledge my amazing wife, Garima, who pushed me to take my writing to the next level. And my son, Arjun, who is the reason I started writing in the first place. I'd also like to thank my parents, who bought me my first Magic: The Gathering cards in an effort to get me to stop playing the Pokémon Trading Card Game as a kid (both published by Wizards of the Coast at the time). Who knew I would be publishing a book on it over twenty years later?

At Abrams, thanks to editor Eric Klopfer for his expert guidance through numerous revisions and keeping the rest of us on track. And to Liam Flanagan, whose graphic design skills brought this book together. Special thanks to artist Tyler Jacobson, who perfectly captured the eclectic cast of characters for our cover.

At Wizards of the Coast, thanks to Daniel Ketchum for his excellent direction throughout the project. And to Jeremy Jarvis and the rest of the Franchise Team who have been great partners over the last two years. My thanks to Worldbuilders James Wyatt and Doug Beyer, who helped polish the content contained within, and to the rest of the Worldbuilding Team, who have brought these Legends to life over the years. Finally, thanks to the Magic: The Gathering editor Nathaniel Moes, without whom this book would be *significantly* harder to read.

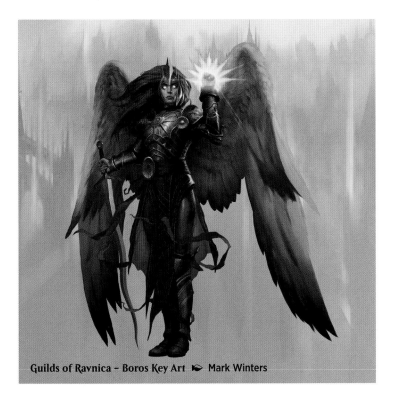

Guilds of Ravnica – Boros Key Art ☞ Mark Winters

I'd like to thank my friend Eric Williamson, with whom I co-authored my first piece on Magic. I'd like to apologize to my co-hosts at The Vorthos Cast: Loreley Weisel, Ashley Barrow, Brian Dawes, and Cary Thomas Barkett, for my many absences as I finished this book. And thanks to Mike Linnemann, who taught me to respect the artists whose work graces these pages.

Finally, a very special thanks to Krenko, a legitimate business-goblin who, despite the slander against his name printed in these pages, was gracious enough to still pose for the cover.

Magic: The Gathering Editor **Nathaniel Moes**
Editor **Eric Klopfer**
Designer **Liam Flanagan**
Managing Editor **Mike Richards**
Production Manager **Erin Vandeveer**

CASE Avacyn, the Purifier ✎ Tyler Jacobson

Library of Congress Control Number: 2019955032
ISBN 978-1-4197-4087-9

Printed and bound in China
10 9 8 7 6 5 4

Abrams ComicArts books are available at special discounts when purchased
in quantity for premiums and promotions as well as fundraising or educational
use. Special editions can also be created to specification. For details, contact
specialsales@abramsbooks.com or the address below.

Abrams ComicArts® is a registered trademark of Harry N. Abrams, Inc.

ABRAMS The Art of Books
195 Broadway, New York, NY 10007
abramsbooks.com